MISÈRE

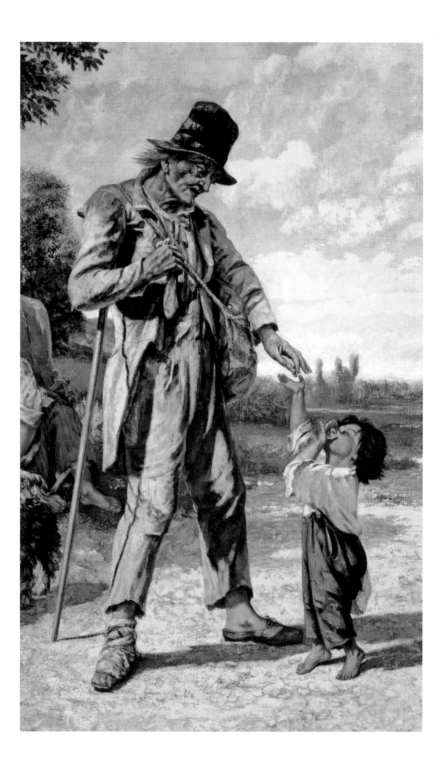

LINDA NOCHLIN

MISÈRE

The Visual Representation of
Misery in the 19th Century

· 128 ILLUSTRATIONS ·

Frontispiece: Gustave Courbet, *Charity of a Beggar at Ornans* (detail), oil on canvas, 83 × 69 in. (210.9 × 175.3 cm), 1868.

Misère: The Visual Representation of Misery in the 19th Century
© 2018 Thames & Hudson Ltd, London
Text © 2018 Linda Nochlin

Designed by Lisa Ifsits

First published in 2018 in the United States of America by Thames & Hudson Inc., 500 Fifth Avenue, New York, New York 10110

www.thamesandhudsonusa.com

Library of Congress Control Number 2017945553

ISBN 978-0-500-23969-8

Printed and bound in China
by C&C Offset Printing Co. Ltd

CONTENTS

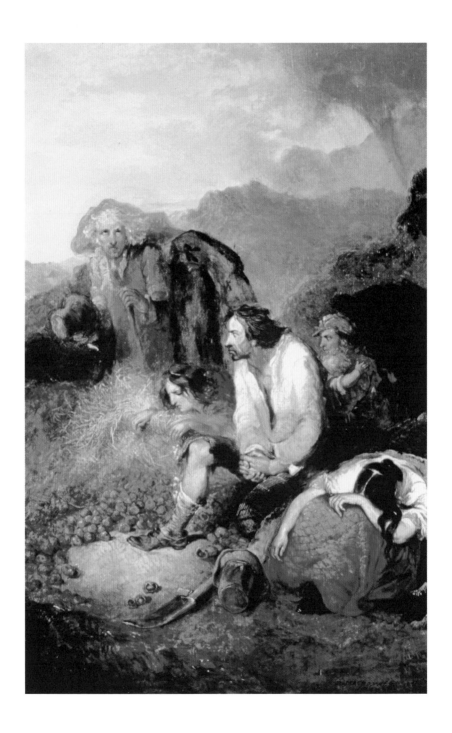

Daniel MacDonald, *An Irish Peasant Family Discovering
the Blight of their Store* (detail), oil on canvas, 1847.

INTRODUCTION

I first encountered the subject of *misère* in 2008 when I came across two modest, gray paperback volumes in a Parisian bookshop. The work in question was titled: *De la misère des classes laborieuses en Angleterre et en France*. Written by a young sociologist, Eugène Buret, the text had originally been published in Paris in 1840; both volumes were republished in facsimile in 1979.[1] Tightly organized, highly informative, as generous in its supply of concrete information as it was cogent in its analyses of facts and statistics, *De la misère des classes laborieuses en Angleterre et en France* was openly and, at times, passionately sympathetic to the harsh fate of the abject poor, and deeply critical of the political and economic situation that had given rise to their plight. Above all, Buret wanted to differentiate contemporary misery from previous forms of poverty and deprivation, both in its severity and its immense impact on the structure of society itself. At the same time, he wished to demonstrate the inextricable connection of working-class *misère* to the economic progress of the Industrial Revolution and the rise of capitalism. *Misère* goes hand-in-hand with the extraordinary growth of wealth. "There is," he declares, "in those nations most advanced in civilization and prosperity, another phenomenon, which is just as worthy as the first of capturing the attention of economists, but which they have all, more or less, neglected": it is *misère*.[2]

It was no mere coincidence that the year in which I discovered Buret's *De la misère*, was also the year of the economic crash in Europe and the United States that caused the devastation of lives worldwide: from loss of homes to loss of jobs to loss of pensions. My uneasiness about the severity of the economic situation and its effects—notably, in the United States at least, broadening the gap between rich and poor—increased my interest in a parallel, if by no means exactly similar, set of circumstances in nineteenth-century Europe.

What specifically did Buret mean by the term "*misère*"? How did he differentiate it from such conditions as "poverty" or "pauperism," which had existed for centuries? Why did he see it as a scourge specific to the nineteenth century and, particularly, to England and France, the most "advanced" nations of Europe? "*Misère*," Buret writes,

> is poverty felt morally. The recognition of evil is not adequately sustained solely by the injury to the physical sensibility; it affects something higher, something more sensitive even than skin and flesh; its pain penetrates to the moral sense. As distinct from poverty, which, as we shall see, is often merely a physical afflic-tion, distress—and this is its constant characteristic—afflicts the whole man, soul and body alike. Distress is a phenomenon of civilization; it presupposes the awakening, even the higher development, of human consciousness.[3]

The onset of *misère* accompanies precisely the economic "progress" that England and France take such pride in: in those countries, declares Buret, "there is to be found extreme opulence side by side with extreme destitution, entire populations, like that of Ireland, reduced to the slow agony of starvation, to the extremes of physical and moral distress; in the very heart of the busiest centers of industry and trade, one sees thousands of human beings reduced to a state of barbarism by vice and misery."[4] Insecurity is one of the prime elements of *misère*:

> Physical and mental misery, the so-called trade crises, are so frequent that they are becoming, it may be said, the perma-nent state of industry, frauds and falsifications of goods have infected almost all branches of business, the disastrous fluctu-ations in the demand for labor, the growth and agglomeration of classes of persons who have no means of existence except sheer wages, often inadequate, always insecure, who have no industry but sheer strength, is the inevitable result of vice and crime."[5]

Above all, Buret insists on the comprehensiveness of *misère* as a human condition—on its mental, emotional and spiritual aspects as well as its merely physical ones: "it is the destitution, the suffering and humiliation that result from forced deprivation, in comparison with the feeling of legitimate well-being, which one sees the whole world attaining at a low cost, or which one had, for a long time, attained for oneself."[6]

As an art historian, I am interested not so much in investigating the nature of nineteenth-century misery itself, but rather in how it was represented in images; not just in high art, but in popular media, such as book, newspaper and journal illustrations. Yet "representation" itself is a problematic term.[7] As we all know, there is no such thing as representation pure and simple, disengaged from ideology.[8] In a sense, representation itself is an ideological formation, corrupted from the start. Nevertheless, in the nineteenth and twentieth centuries, large numbers of artists, caricaturists and photographers—image-makers generally—strove to create in visual terms an accurate, unadorned, "truthful" account of the world of misery, poverty, displacement, disempowerment and alienation, whether in high art, illustration or journalism. The Irish Famine of the mid-century, the world of beggars, the homeless, dislocated urban dwellers, wanderers and tramps, prostitutes, unemployed workers—all were subjects these image-makers turned to.

To frame it another way, I wanted to investigate what one might call the "proto-documentary," the early attempts to capture the effects of hunger, poverty, uprooting and alienation before the existence of the coherent genre of documentary photography. The development of a pictorial language adequate to the representation of misery during the nineteenth century has been relatively uninvestigated. What stood for "honesty," "truth" and "directness" in the formal realm? What styles and expressive strategies best served to capture the reality of misery and, at the same time, arouse sympathy for the *misérables* rather than disgust or rejection?

For my methodological approach, I relied on the brilliant paradigm offered by the literary critic Steven Marcus[9] in his extremely detailed

analysis of the ways contemporary writers attempted to find or construct a language adequate to the unprecedented phenomenon that was Manchester. With few literary or rhetorical precedents for the observers of post-industrial Manchester to fall back upon to describe the disintegration and transformation of the city plan, the debased conditions of labor, the altered structure of the family—in short the totalizing effects of early capitalism—contemporary writers such as Charles Dickens, Thomas Carlyle, Benjamin Disraeli and Alexis de Tocqueville commonly resorted to metaphors from nature. The effect of the use of such metaphors was to naturalize the horrific and unprecedented situations under observation: in other words, to treat the man-made social system as though it was a part of the natural order of things, not the result of human operations and choices.

What sort of visual imagery serves to document the life and appearance of the *misérables* before photography was available? There is some powerful on-the-spot recording in the form of drawing, like the notorious, unskilled sketches (see p. 103) of the half-naked women and children who worked underground, dragging carts in the mines. Created by the untutored draftsmen of the Parliamentary Children's Employment Commission, the images were published in the groundbreaking *Report of the Inquiry into the Employment and Conditions of Children in the Mines and Manufactories* of 1842.[10] But often such visual "documentation" is to be found in the illustrations of powerful and popular nineteenth-century novels dealing with the deplorable conditions of the lower classes: images such as those accompanying Victor Hugo's climactic *Les Misérables* (see pp. 78–79) or Dickens's *Oliver Twist*.

Few readers now, apart from specialists in nineteenth-century French literature, sit down to read Victor Hugo's hefty five-volume, best-selling opus in its entirety.[11] This is a pity in some ways, since not only is it unequaled for the sheer quantity and variety of representations of misery, but it also contains the century's most ample, serious analyses of the concept of justice and human nature itself:

Jean Valjean, the inoffensive tree-pruner of Faverolles, the formidable convict of Toulon, had become capable, thanks to the

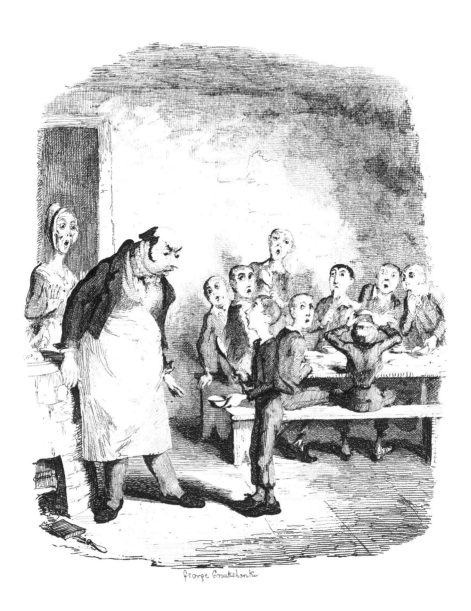

George Cruikshank, *Oliver Asking for More*,
from Charles Dickens, *Oliver Twist*, c. 1837–38.

manner in which the galleys had molded him, of two sorts of evil action: firstly, of evil action which was rapid, unpremeditated, dashing, entirely instinctive, in the nature of reprisals for the evil which he had undergone; secondly, of evil action which was serious, grave, consciously argued out and premeditated, with the false ideas which such a misfortune can furnish. His deliberate deeds passed through three successive phases, which natures of a certain stamp can alone traverse,—reasoning, will, perseverance. He had for moving causes his habitual wrath, bitterness of soul, a profound sense of indignities suffered, the reaction even against the good, the innocent, and the just, if there are any such. The point of departure, like the point of arrival, for all his thoughts, was hatred of human law; that hatred which, if it be not arrested in its development by some providential incident, becomes, within a given time, the hatred of society, then the hatred of the human race, then the hatred of creation, and which manifests itself by a vague, incessant, and brutal desire to do harm to some living being, no matter whom. It will be perceived that it was not without reason that Jean Valjean's passport described him as a very dangerous man.

From year to year this soul had dried away slowly, but with fatal sureness. When the heart is dry, the eye is dry. On his departure from the galleys it had been nineteen years since he had shed a tear.[12]

Hugo's representation of misery is textually dense, capable of swerving and swooping at once. Various diluted representations of Les Misérables show the disintegration and reduction of Hugo's text, the loss of seriousness and devolution into thin amusement. For most contemporary audiences, "Les Mis,"[13] whether musical, film or film of musical, has little or no relationship to Hugo's project. The film and musical adaptations of Les Misérables are written from a particular point of view—that of middle-class Hollywood—with an underlying suspicion and othering of the crowd of shuffling, vaguely guilty, sinister-looking misérables of the Paris streets.

Cuteness as a Strategy:
1832 as a Cute Revolution

There are no "cute" revolutions, although most musical and film versions of *Les Misérables* insist on this, particularly in the case of the appealing figure of the child Gavroche, whose cuteness is his defining characteristic, along with—indeed as part of—his heroic self-sacrifice. Making a character picturesque is an effective way of ideologically disempowering the lower classes, cleverly put to use in the representations of the 1832 Revolution in Broadway and Hollywood adaptations of *Les Misérables*. Look at that cute little barricade, so cunningly concocted from spare bits of this and that by those ingenious radicals! Of course, it is not particularly effective as a barricade, but that is almost beside the point. It is interesting to compare these adaptations to Peter Watkins's memorable anti-documentary film, *The Commune*, of 2000. In Watkins's unusual work, the subjectivity is that of the working classes. They are not figured as furtively scuttling or pitiful for the benefit of a middle-class audience; poverty and oppression are normalized, as it were, not othered. There are no startling effects to capture the viewer's attention or sympathy. Dull grayness and the reduction of accouterments characterize the sets. Above all, the key strategy of cuteness is avoided. Figures like Gavroche and his child companions, patronized in the Hollywood-type versions by ingratiating flashes of charm, are totally eliminated. Watkins realizes that a "cute revolution" is a non-threatening revolution.

Hugo explores many different types of misery from a wide range of vantage points. He contrasts misery with its various contradictories: extreme generosity in the figure of the saintly bishop; extreme injustice in the figure of Jean Valjean, punished for years on end for stealing a loaf of bread; unnecessary cruelty in the case of the galley slaves; and spite that is both willful and will-less in the lodging of the child Cosette. Is the final resolution and (relatively) happy ending of *Les Misérables* convincing? Is it convincing to the modern reader? I think not. I feel that for today's reader, on the contrary, "all that is solid melts into air," to borrow the immortal title of Marshall Berman's book.[14] Redemption

of misery lies not in some fearful return to the constriction of stable or farmland but rather in the open spaces of the modern city with its avid dynamism and ravening creativity.

More arresting images of *misérables* illustrated sensational novels such as *Les mystères de Paris* (1842–43) by Eugène Sue, or, perhaps most effective of all, the highly detailed, often dramatic illustrations from Gustave Doré and William Blanchard Jerrold's monumental *London: A Pilgrimage*, published in 1872. Because of its scope and the multiple and sharply contrasting views of the greatest city of the time, *London: A Pilgrimage*, and Doré's series of 180 engravings in particular, deserve careful investigation.

London: A Pilgrimage is an ambitious work, setting forth in its combination of opulence and squalor images of the indescribable misery of certain quarters of the city with the luxurious splendors of others. This contradiction is central to the definition of *misère* described by Buret nearly three decades earlier: "In the very heart of the busiest centers of industry and trade," Buret argues, "one sees thousands of human beings reduced to a state of barbarism by vice and misery."[15] There is no more precise and striking representation of this quotation than Gustave Doré's illustrations, setting side by side the extravagance of the high life as opposed to the poverty of the urban rookeries. The artist's mastery of the effects of contrasting light and dark—intrinsic to the black-and-white medium itself—accounts for some of the impact of his illustrations. Each image impresses with its veracity in a different way, shifting from close-up to panoramic view; from chaos to mechanically repetitive order; from oblique perspective to frontal, head-on view.

Doré and the writer of the text, Jerrold, in the company of two plainclothes policemen, actually visited some of the horrific scenes later illustrated by the artist, although Doré never sketched on the sites he depicts. Looking at the grotesque extremes of Doré's representations of the urban slum, one can easily draw direct parallels to this artist's earlier work as an illustrator, particularly his vivid compositions for the illustrated edition of Dante's *Inferno*, published in 1861. Some of the grotesque exaggerations in his work may in fact be due more to fantasy than to precise documentation. Doré was criticized for inaccuracy,

for being more involved with aesthetic effects of the real than with realistic documentation. He was especially good at what one might call "effects of squalor."

Nevertheless, by means of skillful and dramatic manipulation of light and shadow, compositional diegesis and brilliant contrast of figure types, Doré brings out the power differentials between the policemen and the wretched poverty-stricken in a work such as the *Bull's-eye* (see overleaf) from the eighth chapter in *London*, "Whitechapel and Thereabouts." The light of the policemen's torch catches the luckless troupe of *misérables*, varied in age and of both sexes, in its geometric illumination. The stark distinction between power and powerlessness is neatly encapsulated in the disparity between those trapped by the beam of the lamp and those wielding it. In a sense, one might say *Bull's-eye* condenses, in a single dramatic image, the effects of misery on an entire urban population.

Wentworth Street, Whitechapel (see p. 89) and *Houndsditch* (overleaf), illustrations to the chapter entitled "Humble Industries," take advantage of the eerie lighting of the poverty-stricken street where the inhabitants, many of them children, are congregated. The young girls, grotesquely garbed in more or less adult garments, set out their wares—broken down, second-hand shoes, used pots and tea kettles—in a passageway congested with ragged vendors. Although Doré probably depicts a daylight scene of marketing, the lane is dark and shadowy. In the text, Jerrold corroborates Doré's impression of the East End rookery: "it is a place," the author declares, "in which day is never aired; in which the sun only hits the highest points."[16]

The appalling misery of these scenes is of course emphasized by the contrasting vision of bourgeois London at its most elegant and pleasurable. At times misery and opulence exist in the same image. In *The River Bank—Under the Trees* (overleaf), for example, Doré contrasts the beautifully dressed ladies and gentlemen watching the boat races, comfortably seated on the ground, with the ragamuffins who have climbed up into the tangled branches of the tree above. The pleasures of the rich—including horse racing, boat racing, balls, receptions and opera—are constantly set in stark relief by the abject poverty and *anomie* of the *misérables*.

ABOVE LEFT
Gustave Doré, *The Bull's-eye*,
from *London: A Pilgrimage*, 1872.

ABOVE RIGHT
Gustave Doré, *Houndsditch*,
from *London: A Pilgrimage*, 1872.

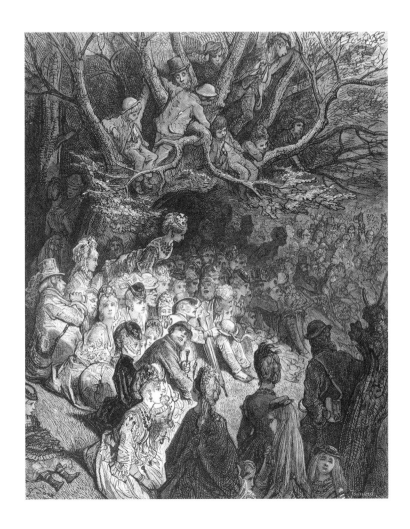

Gustave Doré, *The River Bank–Under the Trees*,
from *London: A Pilgrimage*, 1872.

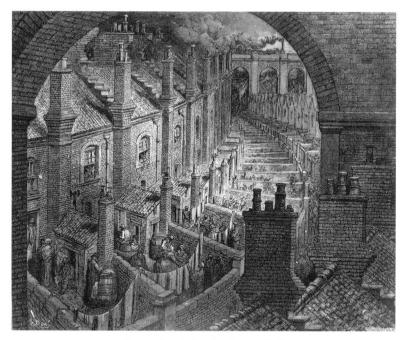

Gustave Doré, *Over London–By Rail*,
from *London: A Pilgrimage*, 1872.

Widely varying vantage points add interest and drama to Doré's depictions: poverty may be viewed close up, as in *Bull's-eye* and in many of his other street scenes, or from a striking distance, as seen in a work such as *Over London—By Rail*, which at once brings out the modernity of the great city and the dehumanizing mechanical repetitiveness that modern advances like the railroad bring to those who live in their shadow.

Of course, *London: A Pilgrimage* was not completely original in its investigation of urban misery. It finds its roots in the seventeenth-, eighteenth- and early nineteenth-century imagery of the *Cries of London* (see p. 23) and, not so far back, in the illustrations, often based on daguerreotypes, for Henry Mayhew's *London Labour and the London Poor*, a four-volume investigation of poverty in London in the 1840s, published in 1851.[17] Yet Doré's representations of urban misery differed from those in both the *Cries of London* and *London Labour and the*

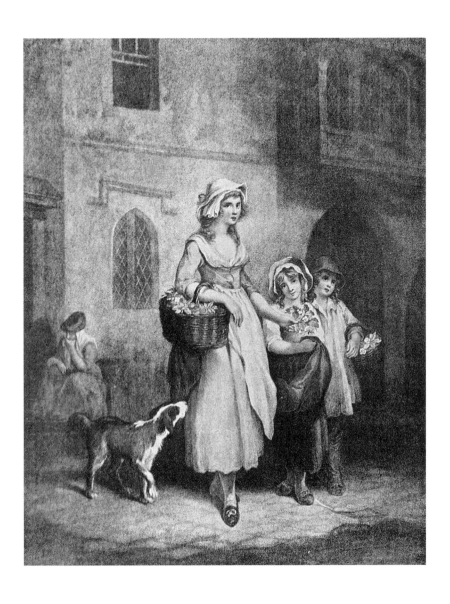

Francis Wheatley,
Two Bunches a Penny Primroses, c. 1793.

Richard Beard, *An Asylum for the Houseless Poor*,
from Henry Mayhew, *London Labour and the
London Poor*, vol. 3, 1851.

London Poor; distinguished from the former by the fact that they totally
avoid the allure of the picturesque in depicting the poor and outcast,
and from the latter in that Doré's illustrations are clearly more dra-
matic and skillfully composed than the rather stiff and awkward social
documentation[18] in the illustrations for Mayhew's text.

In the first chapter of this book, I investigate the Great Irish
Famine of *c.* 1846–51 and Ireland itself as a major example of misery
throughout the nineteenth century, well before and after the specific,
extreme form of destitution caused by the mid-century Potato Famine.
Observers complained that the Irish situation was so overwhelmingly
horrific that words could not describe it. Pictures might do better,
some said, although there were actually no contemporary photographs
of the conditions in Ireland during the Famine years. One newspaper,
the *Illustrated London News*, did commission an Irish journalist and
draftsman by the name of James Mahony to record some of the worst

aspects of the Great Hunger. This popular periodical regularly published accounts of the situation in Ireland, written and illustrated by Mahony, who produced some of the most significant visual testimony of the disaster. I have attempted a kind of phenomenological analysis of some of these newspaper illustrations, both in order to explore the limits of the proto-documentary and to compare the representations of the victims of the Irish Potato Famine with twentieth-century documentation and documentary photographs of famine sufferers.

The following chapter examines gendered representations of misery: those of poor women, and particularly of prostitutes and prostitution in nineteenth-century France. Two exhibitions, *Splendeurs et misères: images de la prostitution, 1850–1910* at the Musée d'Orsay, Paris (2015),[19] and *Edgar Degas: A Strange New Beauty* at the Museum of Modern Art, New York (2016),[20] serve as specific case studies.

Clearly, men and women experienced misery in different ways. If both sexes could sell their bodies for wages in factories, only women could sell their bodies to men for the latter's sexual gratification. Yet to generalize such a practice with the single term "prostitution" is both unjust and inaccurate. Sex work could be a full-time occupation or a part-time one, resorted to when other work for women was scarce. To homogenize the luxurious life of the so-called *Grandes Horizontales*, with their coaches, villas, gorgeous clothing, theater boxes, expensive jewelry and, apparently, sexual power and freedom of choice, with that of the oppressed, impoverished streetwalkers or the abject inhabitants of lower-class "registered" brothels, is patently ridiculous. Despite the apparent objectivity and would-be "realism" of much nineteenth-century visual and verbal representation of female sex workers, the whole area is bathed in fantasy, fantasy generated by male need and desire and the ever-present misogyny that dominates the discourse of both high art and popular texts and images depicting women who deviate from the carefully monitored rules of sexual behavior. The so-called "realism" of the verbal or visual construction of a character like Émile Zola's Nana or one of Henri de Toulouse-Lautrec's prostitutes is as much a function of mythology as is a classical Venus or Aphrodite, different though the presiding myth may be.

Each of the final three chapters is concerned with a different nine-teenth-century artist's works devoted to the representation of misery. The first, on Théodore Géricault (1791–1824), is based on a lecture titled "Géricault, Goya and the representation of misery after the Industrial Revolution," given at the Prado in 2012 and published in Spanish later that year in a collection of lectures titled *El arte de la era romántica*.[21] In this chapter, I am particularly interested in three lithographs, created by Géricault as part of an 1821 series titled "Various Subjects Drawn from Life and on Stone by J. Géricault [*sic*]," and devoted to repre-senting the realities of post-industrial London. Already, in the London lithographs of Géricault, it is clear that the poor old man (see p. 82)—whether beggar or tramp or simply represented sitting or walking—is the prime signifier of misery in the nineteenth century. Unlike the pic-turesque poor folk of earlier typologies, brilliantly analyzed by Sean Shesgreen in his work on the *Cries of London*,[22] these old men are totally lacking in charm and visual allure; on the contrary.

The chapter on Gustave Courbet (1819–77) is based on a lecture I gave on the Irish beggar woman in the left foreground of Courbet's *Painter's Studio* (1855). Titled "Courbet and the representation of '*Misère*': A dream of justice," it was later published as an essay in Klaus Herding's exhibition catalogue *Courbet: A Dream of Modern Art*.[23] Courbet's construction of the very paradigm of the condition of misery in his late *Charity of a Beggar at Ornans* of 1868 (see p. 121), a work that is both unique and outrageous, will be the major object of scrutiny. Has any other artist ever invented a figure as miserable and repugnant as the alms-giving beggar on such a grand scale?

Finally, I will examine the work of the lesser-known artist Fernand Pelez (1843–1913), who specialized in an original and self-conscious representation of contemporary misery. Pelez created a whole series, work after work, featuring different levels and types of poverty, as well as the activities of the down-and-out. *A Morsel of Bread* (1908) features the fate of destitute old men, a subject explored by Vincent van Gogh in his early studies done at The Hague. But Pelez's most important works feature the disaffection and alienation of ambulatory performers in Paris, paintings such as his *Grimaces and Misery: The Saltimbanques* of

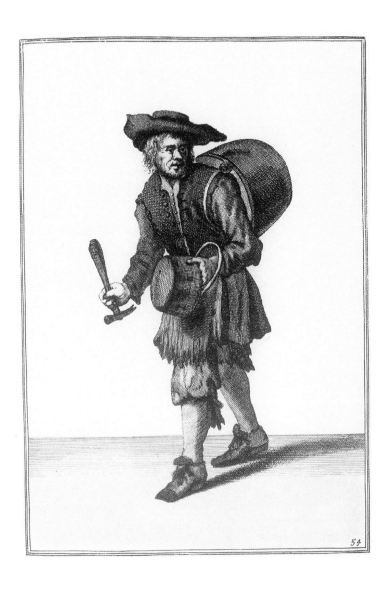

Marcellus Laroon, *A Brass Pott or an Iron Pot to Mend*,
from *Cries of London*, 1687.

1888 (see pp. 144–45), which could have served as an inspiration for Georges Seurat's *Circus Sideshow* (1888).[24]

It is clear that my project is in no sense a "survey" of the representation of misery in the nineteenth century, but is rather an examination of case studies and paradigms. At the same time, I, like my predecessors in the definition and critique of *misère*, must be wary of falling into the trap of historical nostalgia: elevating, as a counter-model to nineteenth-century misery, the communal life of the peasantry during the Middle Ages, the Renaissance, or the pre-modern period—a trap even Karl Marx fell into in his early writings—as a happy alternative to the evils of modern alienation and rootlessness.

Marshall Berman brilliantly defends the countering values of modernity in his classic *All That Is Solid Melts Into Air*, pointing out the freedom, opportunity and escape from small-town oppression and conformity offered by the modern city.[25] The condemnation of nineteenth-century misery in no sense implies a return to the communal life of the poor under the aegis of a feudal lord for those who have been uprooted; on the contrary, it suggests the instauration of a more just, egalitarian and satisfying social order for all.

Misery, and its representation, remains a major issue in the present day and it is now envisioned not merely as a European concern, but as a global one. Perhaps the most ambitious contemporary study of misery is *La misère du monde*, a 1,460-page study and analysis of interviews directed by Pierre Bourdieu. Published in 1993, the text is the result of a human research project headed up by Bourdieu and carried out by his team of sociologists.[26] These interviews explore in the most minute detail the personal difficulties experienced by a diverse group of working-class subjects—native French people, immigrants and children of immigrants from North Africa—many of them out of work and living on the margins of society in contemporary France.

The ethical and moral issues involved in the representation of misery and human suffering generally, and in the so-called documentary project itself, have been raised more and more frequently in the last few years. The visual representation of not just misery but also of more acute forms of suffering has been especially criticized by the artist

Martha Rosler, among many others. As usual, it is visual representation rather than verbal that takes the worst beating: to report verbally on starvation is understood to be less nefarious and self-aggrandizing than to photograph starving people, which is held to "aestheticize" them and make them available for delectation. Why is it always the visual representation of misery that bears the brunt of moral opprobrium? Much visual documentation is far from "aesthetic," unless one begs the question by asserting that *all* images are, *sui generis*, aesthetic; a questionable position indeed.

Nineteenth-century attempts to capture—with more or less exactitude and dramatic expression—the plight of the *misérables* give rise to various questions about similar efforts in the present. How ethical is it to visually represent the poor, the outcast and the degraded? Why does it seem to certain critics today to be unethical to depict these figures? Why do verbal descriptions seem less degrading? For us the question about the representability or unrepresentability of misery is now, at least in part, a moral question. Whereas the issue in the nineteenth century was how accurately and how convincingly one could document misery and outrage—a project that continued through the twentieth century, in work like the Depression-era FSA (Farm Security Administration) photographs—the question in the twenty-first century seems to lie in the moral and ethical dimension of documentary representation itself.

By the mid-nineteenth century, the possibilities offered by photography enabled the documentation of misery, poverty, starvation, child labor, and the like, in a way that no draftsman, however skilled, had achieved. The era of the documentary extended from Jacob Riis (1849–1914) and Lewis Hine (1874–1940) to the documentary photographers of the FSA. Efforts were made to combine the grim realities of privation and homelessness with a sympathetic, emotional charge in the work of Jack Delano, Walker Evans, Theodor Jung, Dorothea Lange, Gordon Parks, Arthur Rothstein, Marion Post Wolcott and others. The more than 175,000 documentary photographs in the digital collection at the Library of Congress bear witness to their attempted veracity by sheer number of images. That the documentary style did not mean a

casual snapshot is attested to by the number of initial attempts before a documentary photographer arrived at the final photograph. The same subject might be shot many times in order to achieve its strongest visual authenticity. It was not until late in the twentieth century that critics such as Martha Rosler began to question the morality of documentary vision itself, claiming that photographs of drunks on the Bowery debased the subjects rather than arousing sympathy for them.

Yet contemporary artists such as Doris Salcedo have attempted to find ways of "documenting" the terror, fear and misery of poverty and political oppression without, so to speak, directly representing them in documentary fashion. Rather, through subtler methods of suggestion and metaphor, an artist like Salcedo can convey the tragedies of the everyday life of ordinary poor and victimized persons. In Salcedo's work, worn-out shoes, broken tables and hanging chairs can suggest tragedy and victimization without resorting to the strategies of the documentary.

MISÈRE:
THE IRISH PARADIGM

In *De la misère des classes laborieuses en Angleterre et en France*, Eugène Buret devotes a short but succinct chapter[1] to the subject of Ireland. That country, he asserts, "is the privileged domain of misery: it is an island as fertile as England; it is inhabited by people dying of starvation and these people don't need any other food but the potato and the worst type of potato, the gross and spongy lumper. And they die of starvation!"[2] Buret then adds: "there are not possible degrees in the misery of Ireland. That nation is miserable to such a point that it only knows a single need: hunger; that it has only a single type of relief: to eat enough to live." "All those who are poor," he continues, "are poor equally and in the same way. They all have difficulty procuring the three pounds of lumper necessary to appease the needs of the digestive viscera each day." Buret goes on to take account of some of the facts and figures involved in the Irish condition, but on the whole refers the reader to the "excellent work of Gustave de Beaumont," which in his opinion "relieves him from studying in too much detail the documents that relate to Ireland."[3]

Gustave de Beaumont's exhaustive study, *L'Irlande sociale, politique et religieuse*, therefore remains the major source of documentation on the condition and causes of the Irish misery up to the year of its publication in 1839.[4] In the case of Beaumont's extremely concrete, well-organized and, at the same time, impassioned study, the reader gradually realizes that in the case of written reports as well as the visual arts, it is not so much a question of the representation of misery *in* Ireland, but of the representation of Ireland *as* misery, the country and

the poor folk of the country standing as the very paradigm of misery in the nineteenth century.[5]

As the editors of the republished text of Beaumont's 1839 volume point out, "Beaumont's modern way of presenting his material and findings resembled what in contemporary social science would be called 'thick description,' after Clifford Geertz."[6] According to the editors, "Beaumont's thick description consisted of a wide range of readings and possible interpretations, usually derived from a broad variety of sources. Detailed note-taking, interviews with experts and other knowledgeable sources, direct observation, the collection and careful study of secondary sources such as journals, government reports, books, and studies, as well as detailed notes from travel books and diaries, all contributed to the final draft."[7] The editors declare: "In addition to the modern format of 'thick description,' the success of *L'Irlande* could also lie in the structure of the book—the political constellation and history were described first, followed by a description of present societal conditions."[8]

What strikes me most about Beaumont is that he manages to do something that is rare in the social sciences today: he combines a ravening appetite for fact, investigation and description with a logic-driven passion for justice and amelioration.[9] The book still remains an inspiring source, both methodological and factual, for the period under consideration; a period that, despite being somewhat earlier than what is usually understood to be the Great Famine, points to the fact that the famine itself was not an anomaly, but an almost continuous or recurring event: "Every year, nearly at the same season," declares Beaumont, "the commencement of a famine is announced in Ireland, its progress, its ravages, its decline."[10]

Some of the earliest significant attempts to visually document misery and starvation in Ireland are to be found in British newspapers, particularly the *Illustrated London News*, which published over forty illustrations between 1846 and 1850 chronicling the effects of the mid-century Potato Famine. Perhaps the most iconic image from the series, *Boy and Girl at Cahera*, by Cork-born artist James Mahony, depicts two adolescents, perhaps brother and sister, on a barren hillside, against a gray sky, searching for potatoes. The boy has paused in his quest and stands to the left, against

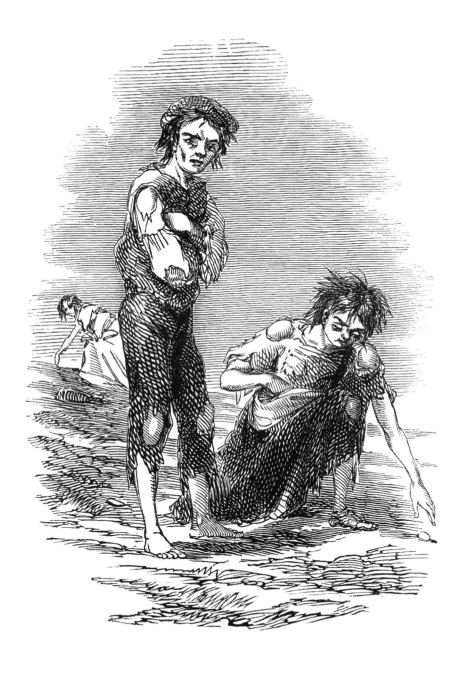

James Mahony, *Boy and Girl at Cahera*, from
Illustrated London News, February 20, 1847.

the horizon, his arms crossed, staring hopelessly into space. His ragged trousers are torn at the knees, his shirtsleeve is covered with holes and patches, and his hair is wildly uncut, visible beneath the shapeless cap on his head. His feet are bare, his cheeks are hollow, his eyes defined by dark rings, his brow furrowed. The girl, crouching to the right, has her hand raised above a single small potato lying on the ground. She is collecting whatever she can find in a sack slung over her shoulder. A bare leg and foot protrude from her ragged skirt, her blouse is a mass of holes from which jut her bony shoulders, and her hair is a wild nest sticking out of her head at all angles. Her eyes are lowered in absolute concentration on her task. Another woman, going about a similar job, is vaguely adumbrated in the background. The two foreground figures, one might say, are misery incarnate: one thinks ahead to the documentary photography of the 1930s, of starving and displaced Okies in the United States, or even of post-World War II images of concentration camp survivors.

The wood-engraving medium, a reproductive technique, with its coarse network of cross-hatchings and straightforward contours, its lack of nuance or subtlety, seems ideally suited to its subject. Its formal contribution to the horror of the scene must have been less obvious to nineteenth-century viewers who simply took it for granted as the medium used in the illustrated journal, and therefore transparent, rather than paying attention to its formal or expressive qualities as *faktura*.

Before we turn to the actuality, to the *specific* misery created by the Irish Potato Famine, we must investigate the meaning of document, documenting and documentary in the context of the Irish Famine. Certainly, the term "documentary" was not in use until the later nineteenth century, specifically in relation to photography. Nevertheless, one might refer to some of the drawings of the Irish Famine as at least "proto-documentary" in their effort to capture the unpleasant details of starvation and debasement brought about by the Famine.

What may be said to characterize the mode of the documentary? The documentary project is in its essence an anti-aesthetic one. It is marked by both incoherence of composition and awkwardness of formal language. In a sense, the lack of aesthetic coherence is understood to be the guarantee of indexical accuracy in the documentary mode.

What was the work of the visual imagery of misery in the early nineteenth century? What was the task of documentary in the wake of the Industrial Revolution or, more specifically, of the Irish Famine? What effects could such an apparently indexical image have? The less aesthetically pleasing and consciously organized such an image might be, the more authentic, the more true to actual experience itself it might be considered. The lack of formal beauty in early proto-documentary imagery functioned as it would later in documentary photography. Jacob Riis, for example, one of the great fathers of documentary photography at the turn of the century, boasted of the fact he was not a trained photographer. He was expressly uninterested in aesthetic quality, and certainly the very ineptitude of his work made it more convincing to the powers that be.

Boy and Girl at Cahera was one of a series of illustrations, accompanied by text, documenting "the unmitigated sufferings of the starving peasantry" in the west of Ireland appearing in the *Illustrated London News*. The editor of that periodical declared in the issue of February 13, 1847:

> With the object of ascertaining the accuracy of the frightful statements received from the West, and of placing them in unexaggerated fidelity before our readers...we commissioned our Artist, Mr. James Mahony, of Cork, to visit a seat of extreme suffering, viz., Skibbereen and its vicinity; and we now submit to our readers the graphic results of his journey, accompanied by such descriptive notes as he was enabled to collect whilst sketching the fearful incidents and desolate localities.[11]

The fact that these are "graphic results" is important. Over and over again, Famine observers emphasize the difficulty or even the impossibility of recording the terrible sights they have witnessed in words. "I have lain awake for hours, struggling mentally for some graphic and truthful similes, or new elements of description, by which I might convey to the distant reader's mind some tangible image of this object," wrote the American philanthropist Elihu Burritt about his visit to famine-struck Ireland in 1847.[12]

In the issue of the *Illustrated London News* of the following week, it is pointed out that "our main object in the publication of this Series of Illustrations is to direct public sympathy to the suffering poor of these localities, a result that must, inevitably, follow the right appreciation of their extent and severity."[13] It is clear that the artist and the editor of the publication face something of a dilemma. On the one hand, the image must convey, as directly as possible, the terrible plight of the starving Irish. On the other hand, famine victims must not be made so repulsive or so alien in their form that the public sympathy they seek turns into disgust and alienation. To this end, the artist James Mahony avoids all reference to the available array of stereotypes of Irish physiognomy current at the time.

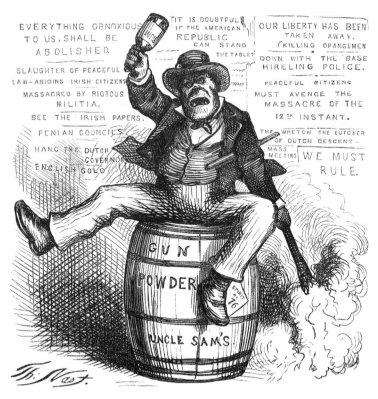

Thomas Nast, *The Usual Irish Way of Doing Things*,
from *Harper's Weekly*, September 2, 1871.

Fig. 747. FLORENCE NIGHTINGALE. **Fig. 748.—BRIDGET McBRUISER.**

Samuel Roberts Wells, *Florence Nightingale* and *Bridget McBruiser*,
in *New Physiognomy, or Signs of Character, as Manifested through Temperament
and External Forms and Especially in the Human Face Divine*,
(New York: American Book Company), 1871.

Popular publications like *Harper's Weekly* and *Punch* often featured caricatures depicting the prototypical Irishman as a snarling, pot-bellied drunk, or, in the case of Irish females, comparing the saintly Anglo visage of Florence Nightingale with that of a coarse, apelike Irish "Bridget McBruiser." Sometimes, in line with certain popular theories of the day, caricaturists compared the Irish physiognomy with that of the "brutish" Negro,[14] an extremely popular subject in the study of physiognomy at the time. There is nothing in the *Boy and Girl at Cahera* to identify Mahony's figures, or many others in this series, as Irish at all, except in the case of figures with identifiably "Irish" items of dress or accouterments. Rags, after a certain point it would seem, have no national identity: they are cosmopolitan signifiers of extreme want and distress.

Another drawing from Mahony's Irish Famine series, appearing in the *Illustrated London News* of December 22, 1849, represents a well-dressed little girl distributing clothing to a group of ragged, half-naked Irish women and children, from the back of a cart that frames her figure and sets it off from the starveling crowd of beggars surrounding it.

33

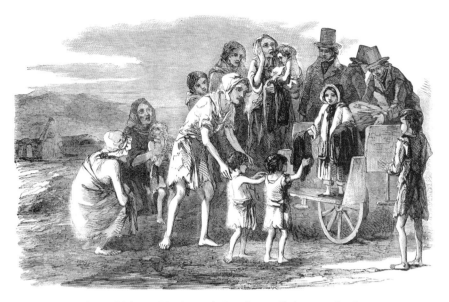

James Mahony, *Miss Kennedy Distributing Clothing at Kilrush*,
from *Illustrated London News*, December 22, 1849.

It is a more complex image with more ambiguous implications than
that of two years earlier, discussed above, in its contrast of the pros-
perous alms-giver with her desperate clients. It is also interesting to
think that the drawing was done only a short time after the various
revolutions of 1848, which had taken place throughout Europe, most
notably in France, in which oppressed populations rose up against
their rulers and established counter-governments, taking matters into
their own hands, however briefly. Here, the opposition between haves
and have-nots has been softened and sweetened by the presence of the
benevolent child: instead of knocking over the cart and appropriating
the clothing, the all-female cast of starving peasants grovels and begs.
(The only male figures are the dignified top-hatted ones behind the
cart, supporting Miss Kennedy's efforts.) And these women are repre-
sented as totally bereft: not only are they starving, skinny and haggard,
but also, at a time when a well-bred woman would shrink from expos-
ing an ankle in public, they are shown as half-naked; a modicum of
dignity is, however, preserved by the ragged bonnets on their heads,

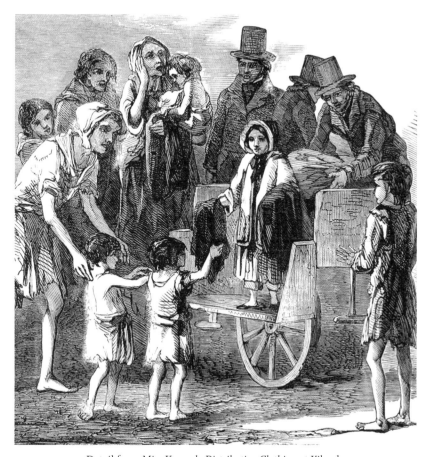

Detail from *Miss Kennedy Distributing Clothing at Kilrush.*

their last tokens of respectability. Nevertheless, as Margaret Kelleher points out in her study *The Feminization of Famine*, "references to women's nakedness pervade famine accounts."[15] Further contrast between benefactor and beggars is provided by the two minimally clad children nearest the cart, who reach out to receive the items of clothing from their elegant little benefactress. The composition mounts up from the total abjection of the grotesquely crouching woman at the far left, to the bare-legged mother introducing the two recipients, to the authoritative pose of the child-donor, elevated on her wagon-platform. She is backed by the added authority of dignified manhood, itself contrasting

with one of the most overtly emotional figures in the image: the openly agitated and grateful mother holding her half-naked child in her arms, who has already received her meager allotment of clothing.

James Mahony comments on his own work as well as the subject of his drawing and its implications in some detail:

> Another Sketch follows (of Miss Kennedy), which shows that, amidst this world of wretchedness, all is not misery and guilt. Indeed, it is a part of our nature that the sufferings of some should be the occasion for the exercise of virtue in others. Miss Kennedy (about seven years old) is the daughter of Captain Kennedy, the Poor-Law Inspector of the Kilrush Union. She is represented as engaged in her daily occupation of distributing clothing to the wretched children brought around her by their more wretched parents. In the front of the group I noticed one woman crouching like a monkey, and drawing around her the only rag she had left to conceal her nudity. A big tear was rolling down her cheek, with gratitude for the gifts the innocent child was distributing. The effect was heightened by the chilliness and dreariness of a November evening, and by the wet and mire in which the naked feet of the crowd were immersed.[16]

This description is followed by further details of, and praise for, Miss Kennedy's charitable undertaking, and the hope that it might be imitated by others. The artist-reporter's account of his work is noteworthy in several respects: the emphasis on extraordinary individual beneficence as exemplary and the tendency to de-humanize the starving Irish women who are its recipients. The crouching woman is reduced to animal status, naked and abject; the humanizing teardrop is mentioned in the text but not represented in the image itself.

The demeaning crouching posture of the woman on the left in *Miss Kennedy Distributing Clothing at Kilrush* is reiterated in the illustration *Searching for Potatoes in a Stubble Field*, which appeared in the same issue of the *Illustrated London News*. This time it is the backside of a young boy, an orthogonal leading the viewer into the picture space,

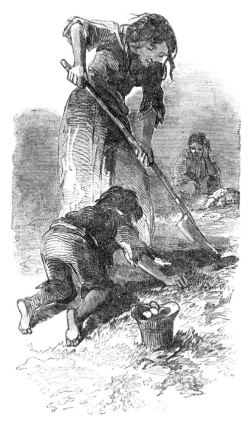

James Mahony, *Searching for Potatoes in a Stubble Field*,
from *Illustrated London News*, December 22, 1849.

that is featured; scrabbling for potatoes in a barren field as a woman behind him, his mother or older sister, frantically wields a spade, her arm crooked up in an angle of extreme effort. In the middle distance of this image is a dimly adumbrated seated form of a mother who failed in the race against starvation, holding her dead or dying child in her arms. The image embodies the sheer desperation of the theme, which Mahony spells out for us in the accompanying text:

> *Searching for Potatoes* is one of the occupations of those who cannot obtain out-door relief. It is gleaning in a potato-field—and

37

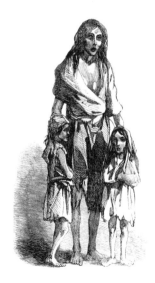

how few are left after the potatoes are dug, must be known to every one who has ever seen the field cleared. What the people were digging and hunting for, like dogs after truffles, I could not imagine, till I went into the field, and then I found them patiently turning over the whole ground, in the hopes of finding the few potatoes the owner might have overlooked. Gleaning in a potato-field seems something like shearing hogs, but it is the only means by which the gleaners could hope to get a meal.[17]

The demeaning and hopeless nature of the task in question is suggested by the debasing figures of speech with which the writer flavors his text—"like dogs after truffles" or "like shearing hogs." These are the verbal equivalents of the scrubby surfaces and unseemly poses in the drawn version.

The reporter goes on to consider the sad fate of one Bridget O'Donnel, represented in *Sketch of a Woman and Children*. "Her story," says Mahony, "is briefly this," and here records it verbatim: "'I lived,' she said, 'on the lands of Gurranenatuoha. My husband held four acres and a half of land, and three acres of bog land…we were put out last November…five or six men came to tumble my house…I had fever, and was within two months of my down-lying (confinement)…I was carried into a cabin, and lay there for eight days, when I had the creature (the child) *born dead*. I lay for three weeks after that. The whole of my family got the fever, and one *boy thirteen years old died* with want and with hunger while we were lying sick.'"[18]

The drawing of Bridget O'Donnel is a remarkable one, both for its accurate documentation of the haggard, ragged, half-naked woman, with her arms set protectively around her equally miserable children—their pathetic, skinny naked legs lined up together—and at the same time the way the image, perhaps unconsciously, reverts back to a prototype that any good Catholic would have known: the historic Virgin of Mercy. The traditional Virgin of Mercy represents Mary as a beneficent mother figure, protecting her vulnerable charges beneath her outspread cloak. The fact that this Irish mother is utterly bereft and has no cloak with which to protect her charges, or even herself,

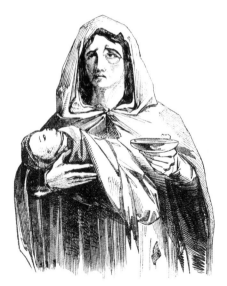

James Mahony, *Woman Begging at Clonakilty*,
from *Illustrated London News*, February 13, 1847.

gives a heightened poignancy to Mahony's drawing, despite, or perhaps
because of, its lack of aesthetic finesse. Strong contrasts of light and
shadow—emphasized by cross- and parallel-hatchings—add further
drama and pathos to the triad.

The image of the mother and child was a popular *topos* for evoking
the misery of the Famine. Mahony resorts to it again in a text and illus-
tration, titled *Woman Begging at Clonakilty*, for the *Illustrated London
News* of February 13, 1847, when he observes from a coach "a woman
carrying in her arms the corpse of a fine child, and making the most
distressing appeal to the passengers for aid to enable her to purchase
a coffin and bury her dear little baby." The artist goes on to recount
that "this horrible spectacle induced me to make some inquiry about
her, when I learned from the people of the hotel that each day brings
dozens of such applicants into the town."[19]

As Margaret Kelleher points out, "one of the most frequent figures in
famine texts is that of the hunger-stricken mother, holding a child at her
breast." She goes on to discuss Mahony's "illustration of a woman carrying

Dorothea Lange, *Migrant Mother*,
gelatin silver print, *c.* 1936.

the corpse of her child," referring to *Woman Begging at Clonakilty*. "The transformation from verbal text, with its realistic detail, to visual image is an interesting one," Kelleher observes. "The spectacle of mother and child becomes iconic, with strong evocations of the Madonna and Child; traces of famine are inscribed on the face of this Irish Madonna through her wrinkled skin, drooping lip and 'staring' eye."[20]

Yet at the same time that this Mother and Child image becomes iconic, both in visual and verbal accounts of the Famine, it remains anachronistic: the Virgin with her dead Son is a reference to a much later occurrence in the Gospels, as recorded in the sculptural theme of the *pietà*, where the Virgin holds her adult, crucified son on her lap: there is no visual or textual prototype for representing Mary with a dead baby in the Gospels. This is a record of contemporary outrage rather than a traditional *topos*. It is hard, indeed impossible, to detach desired objectivity from residual iconicity (this is as true in the case of New Deal documentary photography—such as Dorothea Lange's famous photograph of a migrant mother—as it is in Irish Famine reportage).

Although there were no photographs to record the effects of the Great Famine, there was some "awareness of the underlying image's evidence or of the capacity of graphic realism to furnish pictorial proof of what could be conveyed only indirectly through writing," to borrow the words of Irish literary theorist Luke Gibbons.[21] Certainly, there were discrepancies between word and image as Mahony, in his work for the *Illustrated London News*, reveals.

Gibbons criticizes Mahony for "holding back from depicting the worst atrocities." According to this authority, "there are some grim pictures…but there is no depiction of the hideous scenes described in print that haunted future generations; people eating grass with green stained mouths; dogs digging up cadavers; bodies buried like refuse in mass graves."[22] Some of these restrictions may have been self-imposed in that the purpose of these illustrations was "to direct public sympathy" and motivate charitable action.[23] It is nevertheless a more general condition of images, or proto-documentary images like Mahony's, in their apparent indexicality, to make a more direct and powerful assault on the sensibilities of the observer than words on those of the

reader. To this day, in newspapers and journals, really horrible images (close-ups of wounded soldiers or people with their heads blown off) are not seen on the printed pages. These images are restricted or kept out of newspapers.

We now have to briefly explore the complex set of circumstances surrounding the Famine: What was the Irish Famine? What do all these visual images refer to? What was the actuality of the Famine and how is it represented in images or words? The Irish Famine must be understood as a combination of natural tragedy and economic policy, a natural disaster enhanced and worsened by British free-trade doctrine. The prime minister, Lord John Russell, and his government felt that they did not want to interfere with the natural play of the market, which would presumably adjust itself. Even though there was charity work carried out by the Society of Friends and others, and even though the British themselves created poorhouses and provided very limited relief, in general it was this hands-off policy, the refusal to ship food into Ireland for the starving, that led directly or indirectly to the horrors recorded and depicted by Mahony.

As part of the *Illustrated London News* series, Mahony documents a particularly vicious aspect of the complex results of the Irish Famine, with a sequence of illustrations depicting the *Ejectments* (overleaf).[24] The Irish peasants were forced out of their houses with all their possessions, and their houses were then pulled down and destroyed to prevent them from re-entering. Some of Mahony's ejectments are narrativized and action-based portrayals of the evictions, featuring a larger cast of characters, while others present an isolated figure, the most powerful representation of the destruction of community, family and heritage. The illustrations showing the towns and houses that have been emptied of human possessions and human presence are frightening. They function almost like ghosts, specters of what has been lost.

One of Mahony's most complex drawings, rich in narrative and graphic detail, depicts an ejectment. Published in the *Illustrated London News*'s pre-Christmas edition of 1848, the illustration was accompanied by a scathing article condemning the Irish landlords who were using the crisis to unpeople their property. The first illustration is of an

TOP
James Mahony, *The Ejectment*,
from *Illustrated London News*, December 16, 1848.

ABOVE LEFT
James Mahony, *The Day After the Ejectment*,
from *Illustrated London News*, December 16, 1848.

ABOVE RIGHT
James Mahony, *Scalp of Brian Connor, near Kilrush Union House*,
from *Illustrated London News*, December 15, 1849.

ejectment scene that contained considerable action (*The Ejectment*), and the second the aftermath (*The Day After the Ejectment*). Social historian Margaret Crawford describes the images as follows:

> We see the tenant remonstrating with the bailiff seated aloft a black steed. Meanwhile, the bailiff's men are already denuding the roof of thatch, and driving away the tenant's donkey. Looking on are uniformed officers. Their presence was intended to insure that the bailiff was not impeded in his duties, and to discourage civil disturbance. A second illustration shows the makeshift shelter along the ditch, into which the peasant has retreated. The stance of the main figure in the picture is one of utter despair.[25]

On the roof, two helpers are already pulling the thatch off the cottage, which is destined to be torn to the ground and destroyed. Evictions increased during the late 1840s, but in 1849, in the whole of Ireland, "the constabulary recorded the eviction of 16,686 families, representing over ninety thousand people. In 1850 numbers increased to almost twenty thousand families and over one hundred thousand people."[26]

It is worth considering the larger reverberations of drawings such as *The Ejectment*, given that in the same period, the image of the interior, and of interiority itself, becomes increasingly important in the representational schemes of popular illustration, literature and high art of the nineteenth century. As Ewa Lajer-Burcharth and Beate Söntgen point out in the introduction to their anthology, *Interiors and Interiority*, "the connection between interior space and human interiority has a long and rich history...How did we come to think of subjectivity as inner space to begin with?"[27] In the case of the pictorial genealogy, a relation is forged between "understanding the self as an interior space and the emergence of the suggestive depictions of interiors [not only] in seventeenth-century Dutch painting,"[28] but also in nineteenth-century representation. The authors go on to consider the contribution of architectural space to the process of internal subject formation: "in this narrative, the emergence of the interior as a discrete and individuated space within the house played a major role in the cultural

construction of an interiorized subject."[29] Lajer-Burcharth and Söntgen cite Walter Benjamin, who reflected on the previous century and argued that "the nineteenth-century interior became the privileged site of bourgeois self-definition: it was both the space and the figure of a new, socially specific subjective formation."[30]

It is not, in my opinion, straining the boundaries of this relationship between interiority and the interior to see in the destruction of the interior space of the poor farmer's cottage, described and depicted in the *Ejectment*, the destruction of the selfhood and self-respect of the Irish tenant. In removing the walls of the cottage a meager basis of their self-existence as human beings is destroyed. So, for the victims of the Famine, this was not merely added physical deprivation but deprivation of a spiritual nature. As Eugène Buret has affirmed in his ever-potent definition of nineteenth-century misery: "*misère* is poverty felt morally…distress—and this is its constant characteristic—afflicts the whole man, soul and body alike."[31] The Industrial Revolution, in taking away a sense of place, in taking away the domestic sphere and putting people into anonymous spaces, destroyed their selfhood.

Some reporter/draftsmen were even bolder than Mahony in their attempts to capture the savage truth of the events of the Famine. A series of illustrations of the Irish Famine published in the short-lived *Pictorial Times* tends to be more straightforward about showing the unmitigated abasement of the Irish peasantry. The sequence of 1846–47 featured particularly poignant images, including the representation of humans and animals, particularly pigs, sharing a cramped indoor space in the *Ardcara–Cabin of J. Donoghue* of 1846; or the degrading misery of *Beggars on the O'Connell Estate*. But the *Pictorial Times* only lasted for five years. Its truth to the sordid circumstances did not attract middle-class readers.

The horrid details of starvation are almost never revealed in high art or in the genre pictures of the time that pass as high art. The figures depicted in these Irish genre paintings might look a little drawn, but never skeletal. One of the most popular and prolific Irish genre painters, the Scotsman Erskine Nicol, rarely turned to the more unpleasant side of the Famine years—extreme poverty or deprivation—and when

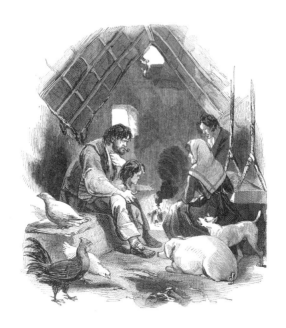

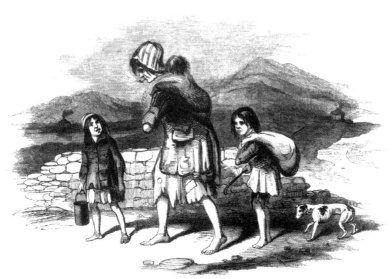

TOP
Ardcara–Cabin of J. Donoghue,
from *Pictorial Times*, February 7, 1846.

ABOVE
Beggars on the O'Connell Estate,
from *Pictorial Times*, February 14, 1846.

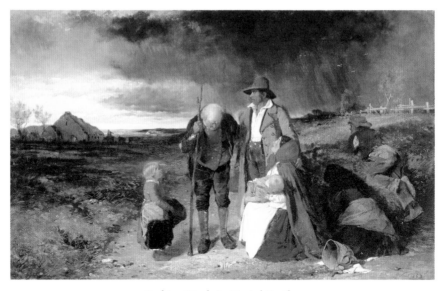

Erskine Nicol, *An Ejected Family*,
oil on canvas, 19 ¹¹⁄₁₆ × 32 ¼ in. (50 × 82 cm), 1853.

he did, softened the blow by making the evicted families appear quite charming and well fed.

Daniel MacDonald is one of the few genre painters who really tried to get at the explicit devastation brought on by the Famine. In his *Irish Peasant Family Discovering the Blight of their Store* (1847), all ages and both sexes are depicted: a ragged child, a father with reddened eyes and torn trousers, a completely distraught young woman and a white-haired old man, possibly a grandfather, in the background, sit or stand. The baby lies unheeded to one side while the old man looks up to the sky.

No account of the representation of the misery caused by the Irish Famine is complete without an investigation of the monuments devoted to its commemoration. What is the work of the memorial monument? It is obviously to recall an event into question, to celebrate specific heroes or to commemorate victims of specific events such as the Holocaust, or, in this case, the Irish Famine, and at the same time to have wider ramifications. Irish Famine monuments may refer to

Daniel MacDonald, *An Irish Peasant Family*
Discovering the Blight of their Store, oil on canvas, 1847.

all victims of oppression, mistreatment and famine, not just the Irish ones, or contrarily may emphasize the specifically national nature of the Irish tragedy, that it occurred in a specific place, at a specific time and to victims of a specific ethnicity. The memorial is usually intended to have an effect on a particular public and its viewers; whether, in the case of the Irish memorials, on the contemporary natives of Ireland in the country itself, or on the people whose ancestors had emigrated during and after the Famine, to remind them both of their Irish ancestry and of this intrinsically national event.

Memorials can resort to sentimentalism, easy emotion and kitsch in order directly to touch the viewers who come into contact with them. In the case of the Famine memorials, the use of human figures generally serves this aim of trying to get the viewer to identify with, and feel compassion for, the suffering of those who experienced the horrors of the Famine. More abstract means are sometimes employed, whether for purposes of money-saving, where a simple Celtic cross might serve the purpose or, more recently, in the interests of a more sophisticated aesthetic and expressive conception. Some of the most effective Famine memorials have been careful to exclude the human figure and instead resort to metaphor or metonymy for their effects.

It is worth considering the limits of representation in memorials. When they involve human figures, they are rarely, if ever, totally realistic. Starvation, deprivation and extreme want may be hinted at, but are rarely depicted with total accuracy. There are several reasons for this: one is that showing the anatomy of actual starving people would not be so much of a commemoration as a turn-off for the viewer. Such decisions (how far to go, and so forth, in the depiction of starvation or suffering) fall within the whole notion of the limits of representation, whether it be simply because human aesthetics cannot match the reality or because the decorum of public monuments demands such limits. When discussing the effectiveness of monuments commemorating the Famine (or any other major outrage, such as the Holocaust), the question must always be asked: Effective to whom? To what audience? To which people? To the contemporary Irish people themselves? To the descendants of the Irish Famine émigrés? To a general population?

What role do words play in the creation of such monuments? In postmodern monuments such as Maya Lin's Vietnam Veterans Memorial in Washington, DC, words and names have had a significant place; indeed, the most effective memorials are thought to be *simply* inscriptions. But inscriptions have always been part of the monumental totality and have contributed to the overall impact. Today, it is the human figure that has been exiled from the most advanced memorials; and yet some of the greatest memorials of the nineteenth century, or of nineteenth-century America at any rate, consist of nothing but the human figure. I am thinking of Augustus Saint-Gaudens' memorial to Clover Adams (1891), a cast bronze sculpture with a granite base that features a seated, heavily shrouded figure. Although Saint-Gaudens titled the sculpture *The Mystery of the Hereafter and The Peace of God that Passeth Understanding*, the local public called it simply *Grief*. Erected at Adams's gravesite, in Rock Creek Cemetery, Washington, DC, the allegorical sculpture is a memorial both to a specific person and to grief and mourning in general. Certainly, the greatest of all Civil War memorials is Saint-Gaudens' *Memorial to Robert Gould Shaw* (1897) in bronze, located at the edge of Boston Common. It combines the idealization of the human figure of Robert Gould Shaw astride his horse and allegory in the form of the classical figure flying overhead, with the deliberate realism of the rows of black soldiers behind the hero. Is it simply not possible to create this kind of figural memorial today or was the Vietnam War so different in kind, too difficult to represent with the pathos aroused by the idealized figure of nineteenth-century memorials?[32]

In the case of the memorials representing the Irish Famine, there are many questions to be asked. There are many such monuments in Ireland itself, some of them created for the official sesquicentenary of the Irish Famine in 1996–97. Margaret Kelleher rehearses with great intelligence the Famine memorials established in Ireland and the United States. She notes that the first memorial constructed in the US to commemorate the sesquicentenary is to be found on Cambridge Common in Massachusetts. Created in 1997, the "modest sculpture comprises four figures: a woman, seated on a rock, is cradling a lifeless

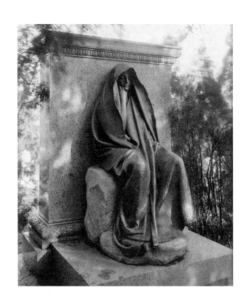

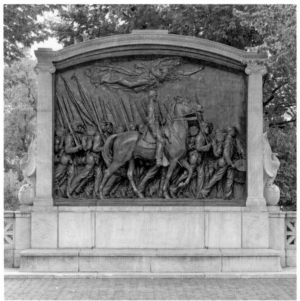

TOP
Augustus Saint-Gaudens,
The Adams Memorial, bronze, 1891.

ABOVE
Augustus Saint-Gaudens, *Memorial to Robert Gould Shaw
and the Massachusetts 54th Regiment*, bronze, 1897.

child while two other children are leaving, one turned towards its mother, the other looking away."[33] Modest in scale, it employs human figures intelligently. In the words of its creator, Northern Irish sculptor Maurice Harron: "It is meant to convey the tragedy, two people dying, two people escaping, the fearful guilt of leaving loved ones behind, and the will to survive, to carry on. These are not heroic figures. They are ragged, emaciated."[34] In Kelleher's words:

> The sculpture is powerfully evocative of the fracture of a family...The adult child turning back towards the past, in contrast to the younger child who looks ahead, brings to mind Walter Benjamin's famous comment on Paul Klee's "angel of history" "looking as though he is about to move away from something he is fixedly contemplating" but irresistibly propelled into "the future to which his back is turned, while the pile of debris before him grows skyward."[35]

Obviously this is in many ways a successful, low-keyed commemoration of the Famine employing the human figures in a suggestive rather than a realistic way. More controversial are such monuments as the *Boston Irish Famine Memorial* of 1998 created by Robert Shure, which is dependent almost entirely on rather banal human figures in two life-sized sculpture groups accompanied by tablets inscribed with text, sited on the Freedom Trail. Naturalistic, attenuated, elongated El Greco-like human figures are the cast of characters in Rowan Gillespie's *Famine* on the Custom House Quay in Dublin, which consists of six life-sized figures (and a dog) in raw unpolished bronze.

One of the most affecting memorials is the *Australian Monument to the Great Irish Famine* at Hyde Park Barracks in Sydney. Although the Sydney monument is dedicated to all of the victims of the Famine, it is inspired by the "Earl Grey scheme," an assisted-emigration policy designed to resettle impoverished young women from the workhouses in Ireland during the Famine years. The 420 names etched in the glass panels of the memorial represent not only all 4,114 workhouse emigrants, but also all those who fled the Famine. Extraordinarily simple

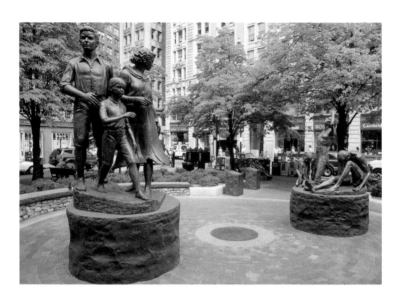

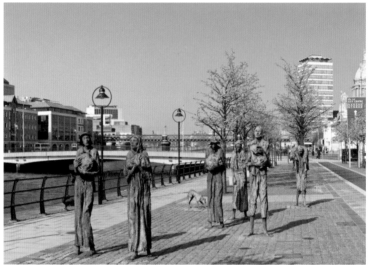

TOP
Robert Shure, *Boston Irish Famine Memorial*,
bronze and granite, 1998.

ABOVE
Rowan Gillespie, *Famine*, bronze, 1997.

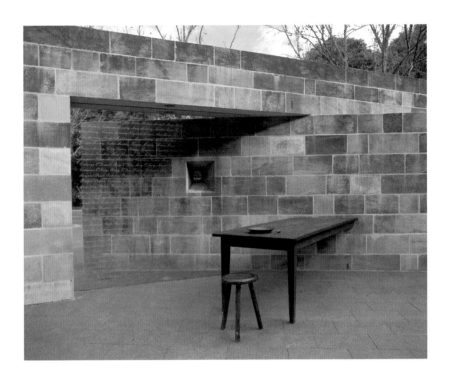

Hossein and Angela Valamanesh,
Australian Monument to the Great Irish Famine,
sandstone, bronze, glass and granite, 1999.

but all the more evocative because of its austerity, it is very effective at doing the work it is intended to do, which is to commemorate these young women while functioning as an extended commemoration of the Famine and of the Famine-era immigrants in general. In my opinion it is one of the most poignant representations of the Great Irish Famine.

The most interesting and complex of all the Irish Famine memorials, and the only one I have personally experienced, is the *Irish Hunger Memorial* at Battery Park City in New York, created by artist Brian Tolle in collaboration with landscape artist Gail Wittwer-Laird and the architecture firm 1100 Architect. It is a literal landscape, "cantilevered over a stratified base of glass and fossilized Irish limestone."[36]

Layered strips of text ranging from the sublime to the horrifying are inscribed on the approaching bearing wall, where, as the historian Simon Schama remarks, "anything resembling a linear narrative of the Famine" has been "studiously avoided, to allow for a display of quotations, homilies, and data recitations." The most striking quote, Schama points out, "is from Charles Trevelyan, the British Treasury official in charge of famine relief, who, as people ate wild cabbage and buried their babies, opined that the best thing for Ireland would be for the misfortune to teach the Irish 'to depend upon themselves for developing the resources of their country, instead of having recourse to the assistance of government on every occasion.'"[37]

The lines of text provide at least a partial preparation for the visitors' pilgrimage through what is basically a landscape site tilted over the ground and looking back onto North End Avenue and forward to the Hudson River. What Simon Schama refers to as an "urban tumulus—in this case, a cantilevered platform of verdure" is "planted with species native to Mayo (one of the hardest hit of the western counties) and strewn with fieldstones engraved with the names of all the counties of Ireland."[38]

One of the main features of this tilted site is the ruins of a real abandoned Irish fieldstone cottage donated by the Slack family of Attymass parish, County Mayo. What is left unexplained, however, is the specific reference of the "ruined cottage." It is quite literally an icon of one of the cruelest aspects of the Famine: the so-called ejectments in

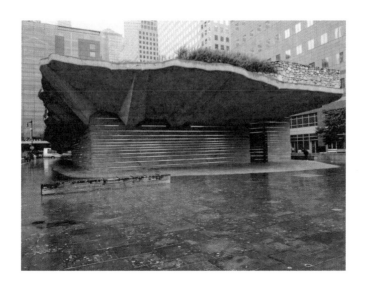

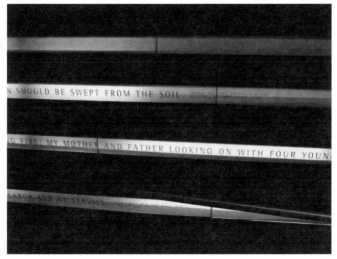

TOP
Shandor Hassan, *Untitled*
(*Irish Hunger Memorial*, Battery Park, New York),
photograph, 2016.

ABOVE
Shandor Hassan, *Untitled*
(Inscriptions at the *Irish Hunger Memorial*,
Battery Park, New York), photograph, 2016.

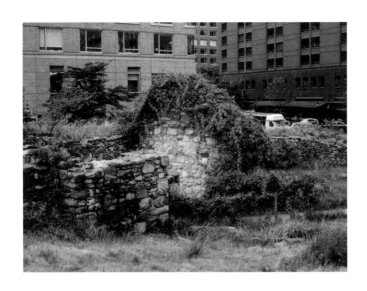

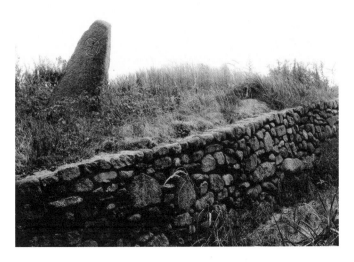

TOP
Shandor Hassan, *Untitled*
(Gravestone at the *Irish Hunger Memorial*,
Battery Park, New York), photograph, 2016.

ABOVE
Shandor Hassan, *Untitled*
(Detail of gravestone at the *Irish Hunger Memorial*,
Battery Park, New York), photograph, 2016.

which starving families were forcibly driven from their homes along with all their meager possessions. The landlords then had the cottage roofs torn off to prevent the inhabitants from ever going back, leaving them totally homeless and starving. Once you know this, the cottage becomes not merely a reminder of old Ireland but also a solidly factual emblem of the outrage itself.

Of course, there are no human figures represented within the memorial. On the contrary, human figuration is provided by the moving bodies of visitors to the site in their pilgrimage up and down the paths winding through the rather wild and weedy plantings; it is certainly not a garden in the usual sense. One highly evocative element is the stone monolith rising like a shark's fin on the south side of monument, beckoning the visitor onward until, close up, it is made readable as a gravestone by the Celtic cross inscribed on its surface. It is a decidedly participatory monument and remains somewhat mysterious in its effects. Because it is, so to speak, open-ended, it can be interpreted both as the Irish Hunger Memorial and as a memorial to the various outrages and unspeakable experiences that have taken place not only in Ireland, but also in other countries.

I myself was aware of various levels of response to the experience of the Famine memorial. It did not immediately recall the specific and painful details of the historic Irish Famine about which I had done so much research; yet perhaps that is not the point. In the rain the general effect was depressing but the feelings aroused were more ambiguous than any direct reaction to the event it commemorated. I was left feeling both enclosed in a significant, if ambiguous, space and at the same time open to other emotions, mostly gloomy and painful.

THE GENDER
OF MISERY

In *De la misère*, Eugène Buret has no hesitation in declaring that women suffer from the depredations of poverty more than men: that the causes and effects of misery are worse for the female sex. After presenting a statistical chart of indigence statistics, he forthrightly declares:

> The most remarkable and the saddest fact that springs from this chart is the disproportion in the number of indigent women compared to that of men. It is almost double. In our society, women have much more difficulty making a living than men, although they have fewer needs and generally have more sober habits. We are not trying to make an emotional appeal—far from it!—but isn't such a result deplorable? The condition of the poor woman, of the woman worker, is frightful.[1]

Buret is equally clear about the relationship between women's resort to prostitution and their desperate economic position: "Certain industries," he asserts, "seem to be organized on purpose to make prostitution a necessity. They are the ones that are subject to periodic, somewhat prolonged unemployment." As a result, "when industry withdraws the employment that provides bread, one resorts to prostitution to get it."[2] Referring to *De la prostitution dans la ville de Paris* of 1836, the scientific study of prostitution by his illustrious predecessor Alexandre Parent du Châtelet,[3] Buret asserts that *misère* is the most important cause of prostitution at the same time that it is one of prostitution's most general effects:

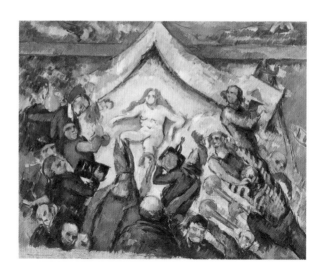

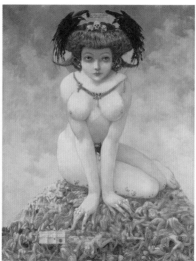

Paul Cézanne, *The Eternal Feminine* (*L'Éternel féminin*),
oil on canvas, 17⅛ × 21 in. (43.5 × 53.3 cm), 1877.

Gustave Adolphe Mossa, *She* (*Elle*),
oil on canvas, 31½ × 24¾ in. (80 × 63 cm), 1905.

Prostitution becomes in its turn, a cause of misery. There is no more miserable condition in the world than that of the girls exploited by the madams of the house, who treat these unhappy creatures like veritable beasts of burden, whose bodies must exhaust themselves for her profit, in exchange for nourishment.[4]

I don't want to make too much of a case for Buret's virtues—to the contemporary reader, the lack of any access to the role of the unconscious is obvious. Against Buret's quite straightforward statements about the inescapable interrelationship of prostitution and misery, one must compare the clearly fantasmic representations of the power and destructiveness of the sexual female body, an all-pervasive misogyny that marks all forms of representation—fiction, poetry, memoirs, letters and the visual arts of the nineteenth century—rising to a hysterical climax near the end of the period.[5] So-called "high art" and the productions of great vanguard artists were no more immune to this totalizing misogyny, wrought both of desire for and fear of female sexuality, than the (now) laughable concoctions of third-rate hacks.

A comparison of Paul Cézanne's *The Eternal Feminine* (c. 1877) with Gustave Adolphe Mossa's *She* of 1905 reveals a startling similarity of attitude towards the sexual female with minor variations. While Cézanne has specified the social identities of the men who have fallen under the spell of the dominating feminine presence, gathered to worship around her altar, Mossa's sinister, huge-breasted, blank-faced *Elle* reigns over an anonymous heap of writhing nude male bodies.

But as crucial as it is to examine the fantasy-fueled representations of the sexual female—or women in general—it is equally important to take note of what has been *omitted* by even the most "sympathetic" or at least most "objective" vanguard artists, such as Toulouse-Lautrec, who haunted the brothel and seemingly had entrée into the intimate lives of its inhabitants. Lautrec depicts the women tenderly caressing each other in bed (see, for example, *The Bed* of 1892), lounging in the salon (see *The Sofa* of 1894–96), or automatically lifting the folds of their *chemises* to reveal their meaty thighs and buttocks while waiting in line for the required physical examination (overleaf).

TOP
Henri de Toulouse-Lautrec, *The Bed* (*Le Lit*),
oil on cardboard mounted on floor board, 121 × 27½ in. (54 × 70.5 cm), 1892.

ABOVE
Henri de Toulouse-Lautrec, *The Sofa* (*Le Sofa*),
oil on cardboard, 24¾ × 31⅞ in. (62.9 × 81 cm), 1894–96.

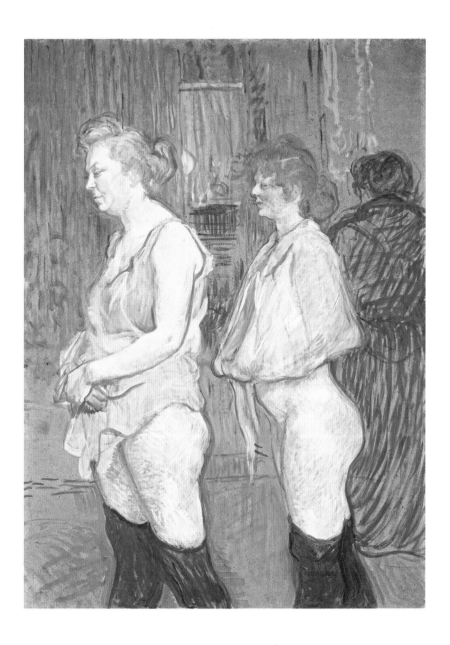

Henri de Toulouse-Lautrec, *The Medical Inspection* (*Rue des Moulins*),
oil on cardboard on wood, 32⅞ × 24⅛ in. (83.5 × 61.4 cm), 1894.

What is never, or almost never, represented is the male figure in a similar situation, and this despite the fact that syphilis and other venereal diseases ran rampant among the male population of France, and specifically among the most innovative artists and writers— Charles Baudelaire, Gustave Flaubert, Van Gogh and many others.[6] Although syphilis is often discussed in memoirs and novels, the syphilitic or potentially diseased male body is rarely, if ever, exhibited in high art, although popular drawings, horrific photographs and caricatures of the depredations of the disease—spots, sores, red welts and, most graphic of all, the loss of the nose and the gaping cavity where it once had been—abound. Yet in high art, there exists no male equivalent for Lautrec's *Medical Inspection* (1894), no male figures dropping their drawers in the interests of science and preventing the spread of venereal disease, although surely some men stood in line for medical attention. The erotic undertow pulls Lautrec's female bodies down into the bottomless sea of naturalized abjection, despite the artist's careful rendition of the humiliation stoically endured by those who had no other way of making a living. Lautrec's presence as spectator, image-maker and participant is manifested in his composition and oddly dry, yet sensual brushwork.

What is also spectacularly absent from the historical record of the nineteenth century, as Charles Bernheimer points out, are any accounts or representations of the experiences of ordinary prostitutes *written by the women themselves*, although there are several highly flavored and narcissistic memoirs written by the great courtesans of the period, eager to display or extol their own desirability in considerable detail.[7] All accounts of prostitution, ranging from the most "scientific," in the case of Parent du Châtelet, who was also, coincidentally, an expert on sewers and their systematization, to the most dramatically subjective, were ultimately imbricated with the male unconscious, its desires, fears and hatreds—the unmentioned, indeed, often unrealized *doxa* of the period.

There is at least one notable exception to the lack of female voices in the representation of prostitution, that of a truly outstanding woman, Flora Tristan, an influential French social theorist and

feminist in the early nineteenth century. In a striking passage from Tristan's *Promenades dans Londres*, first published in France in 1840, in a chapter devoted to prostitution in London, the author describes in painstaking detail the degradation of prostitutes, particularly the way English upper-class males make their prostitute-companions drunk and then, when the poor women are lying senseless on the floor, amuse themselves by pouring drinks on their unconscious bodies. "I have seen," declares Tristan, "satin dresses whose color could no longer be ascertained; they were merely a confusion of filth. Countless fantastic shapes were traced in wine, brandy, beer, tea, coffee, cream and so forth—debauchery's mottled record. Alas! the human creature can sink no lower." Even more concrete is Tristan's description of the fall and desecration of a prostitute, "an extraordinarily beautiful Irish woman," dressed in white:

> She arrived toward two in the morning dressed with an elegant simplicity which only served to heighten her beauty. She was wearing a gown of white satin and half-length gloves revealing her pretty arms; a pair of charming little green slippers set off her dainty feet, and a kind of diadem crowned her head. Three hours later, that same woman was lying on the floor *dead drunk*! Her gown was revolting. Everyone was tossing glasses of wine, of liqueur, etc., over her handsome shoulders and on her magnificent bosom. The waiters would trample her under foot as if she were a bundle of rubbish. Oh, if I had not witnessed such an infamous profanation of a human being, I would not have believed it possible.[8]

The *Splendeurs et Misères* Exhibition: Ambition and Controversy

It is interesting to consider the Parisian blockbuster *Splendeurs et misères: images de la prostitution, 1850–1910*, which took place at the Musée d'Orsay in 2015–16, from the point of view of this universalized

misogyny.[9] The pretense that one can exhibit and discuss the representation of prostitution and the considerable production of outright pornography associated with it, as one could an exhibition of still life or altarpieces, under the aegis of objective scholarship, is farcical, to say the least. A profound awareness of the self as a speaking and sexual subject is necessary. Let me play the reactionary as far as the display of sexualized female bodies is concerned and assert that we need to reintroduce the old *Enfer*, the special collection of erotic and pornographic books buried away safely in the belly of the Bibliothèque Nationale, or at least the idea of one. The *Enfer* at least had the virtue of enforcing a certain self-consciousness on the part of the researcher, of bringing to awareness the fact that one was dealing with hot stuff, forbidden or at least controversial, featuring the naked female and, more rarely, male human body; that one was up against (pleasurable?) verbal and visual stimuli as well as neutral "research" materials. Without such awareness, the supposedly scholarly, public exhibition is, archival or not, a way of allowing or encouraging the museum-going public, its male half particularly, a gratifying wallow in erotica—high, low and all levels in between—that is made palatable by its "educational" quality.

One major aspect of *Splendeurs et misères* was the way the show treated prostitution and prostitutes as one unified sexualized category while, at the same time, contradictorily, setting forth the enormous difference in experience of the *Grandes Horizontales*, the high-class courtesans of the Second Empire (arguably more liberated than any bourgeois woman at the time), and the repressed, enslaved poor prostitutes working in the *maison closes*.

Edgar Degas:
A Strange New Beauty

There were, however, a few artists in the nineteenth century who managed to suggest, through formal inventiveness and complex iconography, an alternate vision. Admittedly, Edgar Degas's monotypes from the years 1877 to 1883 were meant for private delectation rather

than public exhibition, but that is irrelevant to the quality of the artist's brothel project. The Brothel Monotypes, prominently featured in *Edgar Degas: A Strange New Beauty*,[10] the 2016 survey exhibition of Degas's monotypes and prints at the Museum of Modern Art, New York, are too often considered as a unified group of works, inscribing a single discourse of prostitutionality and transgressiveness.

Yet as a group, they are far from unified, ranging from alienating, caricatural coarseness and animalism (see overleaf, for example, *Two Young Girls*, c. 1877–79, or *Waiting*, first version, c. 1879), to representations of relaxed conviviality among women on their own or women with a male client, or women enjoying each other's bodies, to a kind of melting bodily unification, a dark, dreamy, fingerprinted figuration of flesh finding satisfaction in flesh, inscribed in compositions in which centripetality—in one case, around a hearth (*The Fireside*, c. 1876–77)—is often the controlling compositional feature, and formal blending, dissolution of borders and material unity the strategic constructive principles. Boundaries and oppositions are obfuscated in these amazing prints, suggesting an almost palpable yearning for that ultimate, even pre-Oedipal, unification with the object of desire— a total and fantasmic satisfaction of the flesh.

In the Brothel Monotypes and elsewhere, Degas positions the male client or benefactor at the very edge of the frame and renders him an abject, timid milquetoast (see p. 72, *The Client*, c. 1879). There is an enormous difference between Degas's subtle representation of men in the brothel and Jean-Louis Forain's *The Client* of 1878 (see p. 73) in which a brutal, controlling top-hatted male figure gloats over his titillating semi-nude female possessions.

Prostitution and the Narrative of Modern Life

Among the artists attempting to create an equivalent of modern experience, while avoiding the strategies of soon-to-be triumphant modernism, Jean Béraud, whose work appeared in the *Splendeurs et misères* exhibition, provides some of the most interesting and suggestive examples.

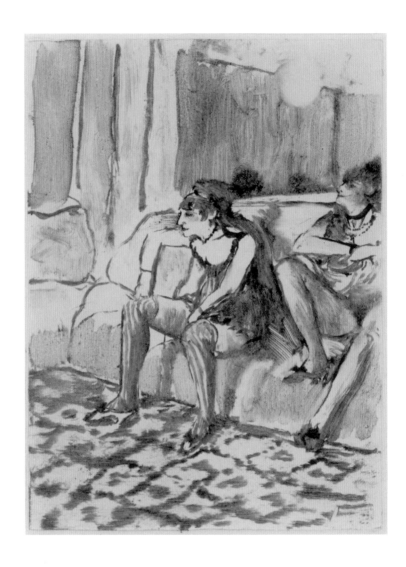

Edgar Degas, *Two Young Girls* (*Deux jeunes filles*),
monotype on China paper, 6¾ × 4³⁄₁₄ in. (15.9 × 12.1 cm), c. 1877–79.

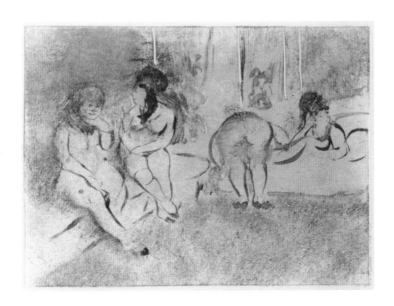

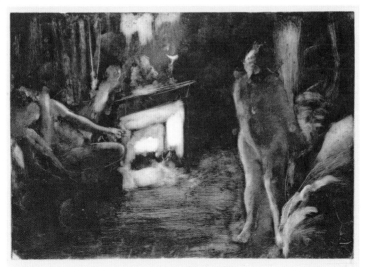

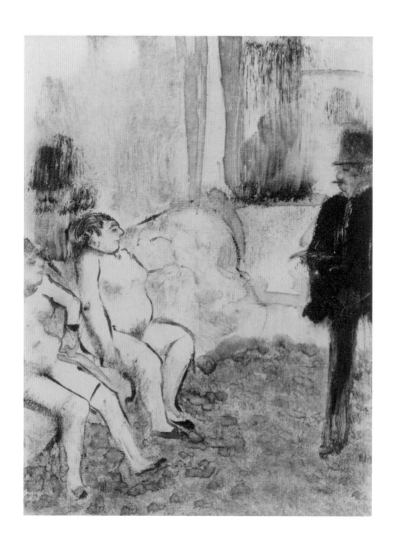

Edgar Degas, *The Client* (*Le Client*),
monotype on paper, 8⁷⁄₁₆ × 6¼ in. (21.5 × 15.9 cm), 1879.

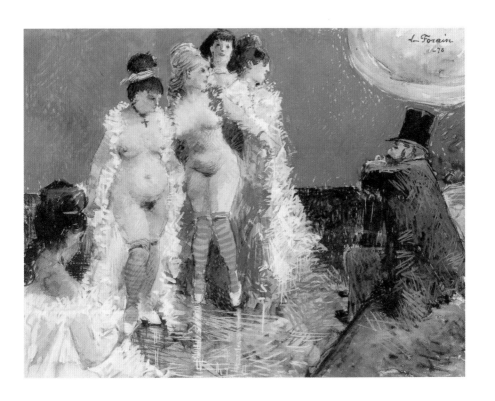

Jean-Louis Forain, *The Client* (*Le Client*),
watercolor and gouache on paper, 9¾ × 12¾ in. (24.5 × 32 cm), 1878.

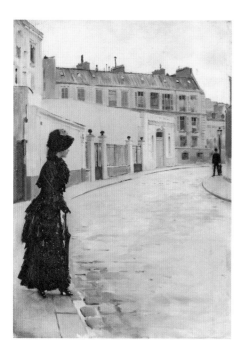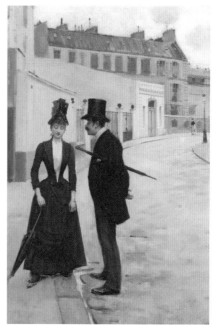

Jean Beraud, *Waiting* (*L'Attente, rue Chateaubriand, Paris*),
oil on canvas, 22 × 15½ in. (56 × 39.5 cm), 1885.

Jean Beraud, *The Proposition* (*La Proposition* (*Rendez-vous rue Chateaubriand*)),
oil on canvas, 22 × 15½ in. (56 × 39.5 cm), c. 1885.

In two related works of 1885, *Waiting* and *The Proposition* (or *Rendez-vous rue Chateaubriand*), Béraud follows the sequence of seduction. In *Waiting*, the would-be seducer is envisioned leaning on a lamppost in the distance. His "prey" occupies the right foreground. The figure is roughly painted and the details of her clothing are significant: chopped, irregular and on the verge of raggedy. I cannot help, in this case, comparing in my mind Aby Warburg's vision of the liberating, expansive function of drapery in his beloved classical *Nympha* with Béraud's streetwalker, for whom drapery, on the contrary, debases, demeans and constricts.[11] In the related Béraud work, *The Proposition*, the "masher," in arrogant, forward-thrusting profile, confronts the shabby little street girl, her too-short sleeves, floppy shoes and battered umbrella indicating her poverty and helplessness, within an urban setting of scrupulous naturalism. Narrative continued to play an important role in the nineteenth-century construction of gendered misery, in the increasingly popular realm of illustrated fiction.

The Powers of Illustration: Cosette

Book illustration—the representation of a representation, as it were—is one of the richest fields of representational investigation of gendered misery in the nineteenth century. Pot-boiler serials in both France and England—like Eugène Sue's *Les mystères de Paris*, published as a ninety-part serial between 1842 and 1843, were printed with original images in a wide variety of styles and qualities (mostly low). On the other hand, illustrations of certain major novels, such as those by Alfred Richard Kemplen for the 1878 edition of Émile Zola's *L'Assommoir*,[12] constitute serious attempts to capture the mood and the setting of the incident in question. One such image, titled —…*"Sir, please listen"…The man gave her a side glance and went on, whistling even louder.*—, establishes a sinister setting of urban entrapment and isolation appropriate to the miserable plight of the protagonist. Gervaise, once strong and feisty, is now cast out and reduced to furtive beggary and prostitution. She timidly accosts a carefree, whistling man, who ignores her after a sideways

look and goes off whistling even louder. The repetitive pattern of paving stones and masonry emphasizes the harshness of the urban scene; a sense of hopelessness and dehumanization is reinforced by the dark perspective leading nowhere at the left and the peeling posters behind Gervaise's pleading figure. The posters provide a grim contemporary context for Gervaise's character, underscored by the stringent regularity of the window bars at right.

Of course, the most astounding example of the narrative of nineteenth-century misery is Victor Hugo's eponymous *Les Misérables,* which first appeared in five volumes in 1862.[13] Certainly, one of the most frequently pictured "heroines of Misery" is the figure of Cosette, the much abused, abandoned and betrayed little protagonist of that "supernovel"—later play, musical and film. Abandoned by her unmarried mother, Fantine, Cosette is handed over to be "cared for" by the corrupt Thénardiers, who, instead, exploit and victimize her, making her do heavy work beyond her childish strength, depriving her of her beloved dolls, and dressing her in rags. The range of representational strategies is wide and varied (see overleaf): at times, reduced to an austerity as poignant as that of the Le Nain brothers' seventeenth-century paintings of peasant life, Cosette's abjection is only suggested by the heavy wooden pail she carries in a work such as Gustave Brion's *Cosette,* from the original illustrated edition of *Les Misérables,* of 1862.

At other times, in illustrations by the same artist, the pathos is intensified by the contrast between the heavy, rough pail Cosette carries in the foreground and the elegant dolls deployed in the shop window she gazes at above. It is significant that when Jean Valjean first encounters Cosette, whom he tries to protect and elevate, he seizes the overlarge wooden bucket from her hand. Variants on the bucket-seizing episode abound, sometimes with the added pathos of a shop window offering unavailable dolls to the abject little pail-carrier in the foreground. In an illustration from 1886–87, this time by Adrien Marie, the rag-clad Cosette is depicted sheltering under the table with her dog bowl of food. One of the most graphic and overtly expressive of the representations of the abused Cosette slaving in the inn of her betraying "protectors," the Thénardiers, is the version by Émile Bayard of

Alfred Richard Kemplen,
—…"Sir, please listen"…The man gave her a side glance and went on,
whistling even louder.— (—…Monsieur, écoutez donc…L'homme la regarda
de côté et s'en alla en sifflant plus fort.—), from Émile Zola, L'Assommoir
(Paris: C. Marpon et E. Flammarion, p. 434, 1878).

Gustave Brion, *Cosette*, from Victor Hugo,
Les Misérables (Paris: J. Hetzel et A. Lacroix, p. 208, 1862).

Gustave Brion, *She could not take her eyes from that fantastic stall*
(*Ses yeux ne pouvaient se détacher de cette boutique fantastique*),
from Victor Hugo, *Les Misérables* (p. 208, 1862).

Gustave Brion, *The child was not afraid* (*L'enfant n'eut pas peur*),
from Victor Hugo, *Les Misérables* (p. 209, 1862).

1886. Here the identifying bucket is isolated against the back wall, the Cosette figure, barefoot and in rags, struggling to manipulate instead an oversized broom as she looks up with a wary glance.[14] In each case, the plight of the protagonist is emphasized by the size and condition of her accouterment. When the character is female, poor and oppressed, the world of things with which she is surrounded almost overwhelms her.

· 3 ·

GÉRICAULT, GOYA AND THE REPRESENTATION OF MISERY

The French artist Théodore Géricault created the large lithograph *Pity the sorrows of a poor old man! Whose trembling limbs have borne him to your door* during a visit to London in 1821 (p. 82).[1] It represents a drunken old beggar, half unconscious, sprawled out on the pavement in front of a bakery window, leaning for support against the brick wall behind him, his left leg awkwardly extended onto the cobbled road. Its title based on a popular poem of the time, the image suggests that this worn-out mendicant, his right hand still outstretched to receive coins, had once led a more prosperous life.[2] The multiple layers of clothing Géricault has so carefully designated refer at once to his home-lessness—he is forced to wear everything he owns—and his better past. His gentlemanly top hat is broken and crumpled; his once sturdy shoes now display holes. Moreover, what we can see of his shadowed face is handsome, quite refined in fact. It is not caricatured or grotesque, and definitely more appealing than the faces of the vulgar commercial couple to the left.

Géricault has created the pathos of his image through a series of understated emphases and contrasts: the open, relaxed gesture of the poor old man as against the vulgar, grasping gestures of the bakery woman and her customer; and the gently reassuring gesture of the dog's paw on the beggar's knee. The dog, clearly a mutt, is positioned as the only living creature to care about his master, this remnant of humanity, discarded on the streets of London.

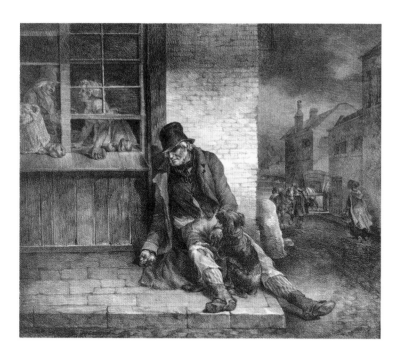

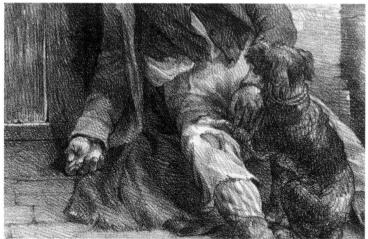

Sir Edwin Henry Landseer,
The Old Shepherd's Chief Mourner,
oil on panel, 18 × 24 in. (45.7 × 61 cm), 1837.

This grouping—the knee, the paw, the dog—is surely the center point of the print. Far from being a trendy *punctum*, Roland Barthes' designation of an irrelevancy that captures the eye of the photo-viewer, this detail lies at the very heart of the lithograph's meaning: a diminished yet intense and intensely moving synecdoche of lost feeling and humanity, caught within the immense social uncaringness of post-industrial 1820s London with its blank surfaces of brick and stone. As such, it is a very different trope from that of Sir Edwin Landseer's similar but slickly sentimental *The Old Shepherd's Chief Mourner* of 1837, with its faithful sheepdog keeping watch over his master's coffin.

The figure group in *Pity the sorrows...* is set against the variegated inorganic background of the urban environment: to the left, the bars

Detail from *Pity the sorrows
of a poor old man!....*

of the bakery window, the animated figures, male and female, half in, half out, the bread on display but out of reach for the poor old man; the woody, textured verticals of the boards contrasting with the beautifully modulated and intensely detailed texture of the brickwork against which he leans and the irregular, larger paving stones on which he is seated, with one leg thrust out into the cobbled roadway to the right. There, the mundane life of the great city hurries on under the grey, fog-clouded light of dusk (or dawn). The garbage collector guides his horses up the cobbled road while a cloaked and bonneted female figure hurries down it, intent on some errand. Thus extreme poverty is contrasted both with petit-bourgeois commerce, working-class physical labor at its most degraded and, far off in the distance, rising like a vision out of the fog, across the river over Blackfriars Bridge, the commercial heart of the great city, and its spiritual manifestation—the City with a capital C and St. Paul's Cathedral. But it is we, the viewers of the print, who must provide, or unpack, these meanings. There is no

trite symbolism or obvious moralization within the framework of the print itself, a lithograph conceived under the aegis of a scrupulous and objective realism. For it is the stylistic structure of the composition that gives it its memorable power: Géricault leaves out nothing, generalizes not at all, provides the viewer with a feast of information and meaningful relationships, from which the discerning eye must pick up the latent meanings.

Géricault created this lithograph on his second trip to England in 1821 as one of a series of twelve prints with a cover, titled *Various Subjects Drawn from Life and on Stone by J. Géricault* [sic] and published by Rodwell and Martin.[3]

When the artist had first visited England, in 1819, accompanying his gigantic *Raft of the Medusa* to its triumphant and commercially successful London exhibition at the so-called "Egyptian Hall" under the aegis of the entrepreneur William Bullock,[4] he had not appreciated the art of his English contemporaries. But on his second visit he had an extreme change of heart, one might almost say an epiphany. Géricault, sensitive to the social radar of the moment, now saw that the more democratic art of England, deliberately unelevated, emphasizing genre, landscape and the portrait, engaged with the telling details of the everyday contemporary life of its variously classed people, was the art of the future, not the pompous, academic, would-be traditional set pieces of the Academy. He understood that England, a leader in commerce and manufacture, trade and spectacle—the innovator of the Industrial Revolution—was also producing this new kind of art, an art he wished to participate in the production of, for reasons that included money making. The lithograph was the up-to-date medium of the time, as he wrote to his friend the painter and lithographer Nicolas Charlet,[5] and the depiction of the lower classes in their daily activities the subject.

On May 1, 1821, after seeing the summer exhibition of the Royal Academy, Géricault writes to fellow-artist Horace Vernet an enthusiastic letter:

> I told my father the other day that the only thing your talent
> lacked was to be steeped in the English School; I repeat it to

you, since I know that you have appreciated the little that you have seen of its works. The Exhibition just opened has again confirmed me in the belief that colour and effect are understood and felt only here. You cannot imagine the beauty of this year's portraits, and of many of the landscapes and genres, and of the animals painted by [James] Ward and by Landseer, aged eighteen—the Old Masters themselves have not done better in this line. One must not be ashamed to go back to school: in art one arrives at beauty only by comparisons. Every School has its character. If only one could unite all these qualities— would that not be perfection? It takes constant effort, and great love. I see that the painters here complain that their drawing is inferior, and envy the French School as the more accomplished. And don't we, too, complain about our faults? What stupid pride closes our eyes to them? Can we bring honor to our country by refusing to see the good wherever we find it, and by insisting, foolishly, that we are the best? Shall we always be our own judges? Won't our works, mixed in the galleries with others, some day proclaim our vanity and presumption? I formed a wish at the Exhibition that a number of paintings then before me might be placed in our museum. I wanted them to be a practical demonstration, more useful than prolonged reflection. How I wish that I could show, even to some of our ablest artists, these portraits that so much resemble nature, whose easy poses leave nothing to be desired, and of which one could truly say that they only lack speech! How useful it would also be to show the touching expressions in [David] Wilkie's work! In one small picture, of a very simple subject, he has brought off an admirable effect. The scene is laid at the Veterans' Hospital: at the news of a victory, these veterans have gathered round to read the *Gazette* and to rejoice. He has varied all these characters with much feeling. I shall mention to you only the one figure that seemed the most perfect to me, and whose pose and expression bring tears to the eye, however one might resist. It is the wife of a soldier who, thinking only of her husband,

scans the list of the dead with an unquiet, haggard eye…Your imagination will tell you what her distraught face expresses. There are no signs of mourning, on the contrary, the wine flows at every table, nor are the skies rent by ominous lightning. Yet Wilkie achieves the last degree of pathos, like nature itself. I am not afraid that you will accuse me of Anglomania; you know as well as I what is good in us, and what we lack.[6]

Géricault's series of prints indeed deals with various subjects offered by the British scene of the time, disparate types, activities and classes, with horses—racing, out for a run, drawing heavy loads, being groomed or shod—prominent among them. Géricault is as interested in horses of different species and social classes as he is in humans.

But none of the English lithographs is more poignant or memorable than the three devoted to *misère*—to the fate of the most poverty-stricken, isolated and dispossessed of the London poor: *Pity the sorrows of a poor old man…*, *A Paralytic Woman* (p. 93) and *The Piper* (p. 101). There is nothing like these prints in the entire visual repertory of misery, either in the period following the Industrial Revolution, before it—or ever, in my opinion. In the words of Régis Michel, who, along with Lorenz Eitner, has written most incisively about Géricault: "The printmaker tracks down the misery-filled margins of a proletarian city. He is probably the *first* to make himself the interpreter of the lower depths of the metropolis: to criticize by means of the image the social cost of the Industrial Revolution."[7]

Strikingly, bricks and brickwork are omnipresent in the settings of all the prints featuring misery in the series, as well as in its closing iteration, the *Adelphi Wharf* (overleaf), with its dark finale of horses entering a closing archway. Brick architecture functions as metaphor, metonymy and environmental reality for the representation of London misery. It is the very sign of the new, overcrowded, poverty-stricken London of commerce and industry. However, on the formal level, brickwork functions as a kind of proto-grid, holding the surface of the paper at the same time that it menaces with its structural monotony and depressing closure. The brickwork grid is at one with the menace of death in the

Théodore Géricault, *Entrance to the Adelphi Wharf,*
lithograph, plate 11 in *Various Subjects Drawn from Life on Stone*
(London: Rodwell and Martin, 1821).

graveyard to the left of the paralytic woman, but it makes its case for
mortality in the setting of the other two misery lithographs as well.

Later, in Gustave Doré's illustrations for *London: A Pilgrimage* of
1872, the quintessential visual compendium of London life in the nine-
teenth century, brick architecture will be of the essence in creating
suitably squalid settings for the misery of the poor in the wake of the
Industrial Revolution.[8]

Pity the sorrows... had abundant literary sources, mainly in variations
of a popular children's poem of the era, which had been published in
both book and broadside form. The caricaturist James Gillray made use
of the "Pity the Sorrows..." theme to represent a hypocritical Edmund
Burke begging for funds in 1796. It is unlikely that Géricault knew the
children's verse, or more than its first few lines, and even more unlikely
that he was aware of Gillray's caricature—I am just mentioning these

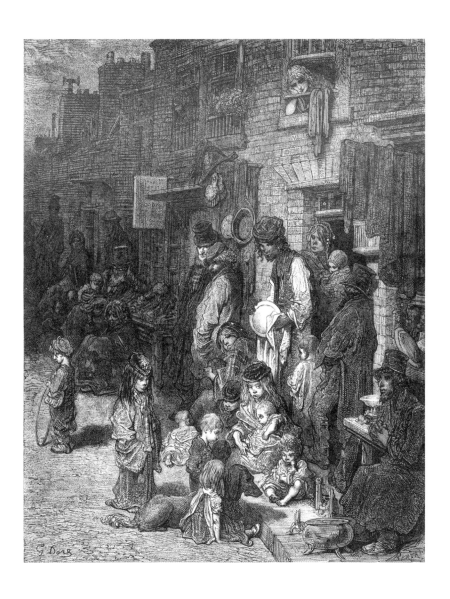

Gustave Doré, *Wentworth Street, Whitechapel*, c. 1869–72,
from Gustave Doré and William Blanchard Jerrold, *London: A Pilgrimage*, 1872.

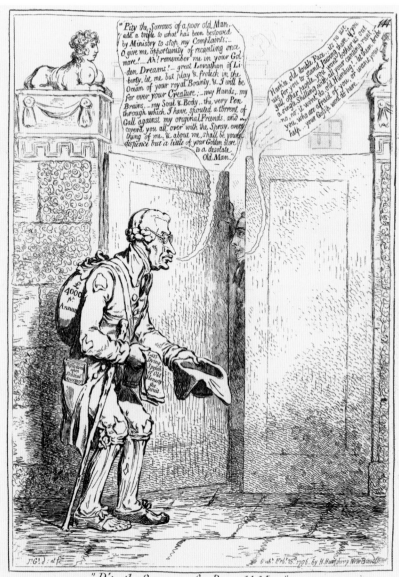

James Gillray, *Pity the Sorrows of a Poor old Man*,
engraving of Edmund Burke begging, 1796.

G. F. Cruchley, *Cruchley's New Plan of London
Improved to 1826* (detail).

two examples to give an idea of the currency of the theme at the time
Géricault made the print. The specificity of the site Géricault chose
to locate his beggar is attested to by finding it on a map of London
of 1826 (see above), which places the poor old man on the pavement
in a lower-class neighborhood on the South Bank, diagonally opposite
from St. Paul's Cathedral and across the Thames by way of Blackfriars
Bridge. Géricault even devotes a separate print to a seemingly minor
element of the lithograph, the dustman with his cart and horses in the
background: he wants to get it just right.[9]

The underlying narrative and the implicit interaction, of sim-
ilarity or contrast, among the characters, and of the characters with
the setting, is even more evident in *A Paralytic Woman*. Consider the
striking difference between the delicate passivity of the protagonist,
propped up like a corpse in her wagon, and the monstrous coarseness
of her attendant, who has stopped for a moment to lean against her

Théodore Géricault,
The Dustmen (*Les Boueux*), lithograph, 1823.

Théodore Géricault, *A Paralytic Woman*, lithograph,
plate 9 in *Various Subjects Drawn from Life on Stone*
(London: Rodwell and Martin, 1821).

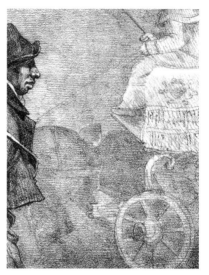
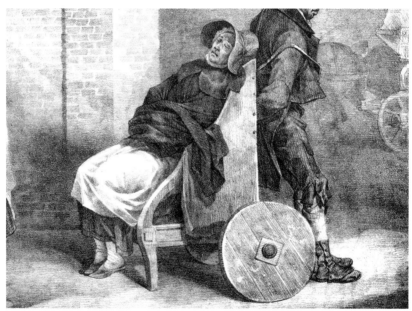

Details from *A Paralytic Woman*.

primitive wheelchair. Other implications derive from the vertically fenced graveyard prominent in the background with its posted hand-bill reading "for all sickness and the…" (opposite, top left). We don't know what the medicine purports to cure, but it probably refers to the unmentionable disease suffered by the female victim. Another mean-ingful but unemphatic contrast on offer is that between the splendid horse-drawn hearse in the background to the right (opposite, top right) and the poor, ad hoc, not-quite-funereal vehicle in the foreground. Or consider the one between the elegant toy horse carried by the richly clad little boy in the foreground and the elegant rump of the wealthy man's funeral horse profiled in the background. A distinct narrative tension is created by the enigmatic glance—malevolent or frightened or both—that the nursemaid leading the child casts back over her shoulder at the paralyzed woman. Is it syphilis, the prime urban disease for women, that is hinted at here? We do not know.[10]

Once more, Géricault focuses with absolute concentration on spe-cific details of class, setting and texture. Brick again defines the urban environment. Wood is grainy; rags contrast with proper clothing; both lumber and paper are detailed in their surfaces; light and dark are appropriately distributed in London's fog-polluted air. As in *Pity the sor-rows…*, the architectural framework is a protagonist in the creation of a meaning that is social, economic and psychologically individuated at once. The miserable *Paralytic Woman* and her attendant are framed by the stout vertical of the end of the graveyard on one side and the background processional of prosperous mortality on the other; the observing nursemaid and her charge are thrown into relief by the brick rectangle directly behind them and reiterated in the stern repetition of the enclosing rails above. On second thought, this print may have a double focus: the down-and-out, grotesquely ugly attendant is as much an alienated figure from the lower depths of London as his unconscious female burden and, as such, equally entitled to our concern.

Francisco Goya, too, represented the miserable class of the society of his time. He did several series of drawings devoted to the subject of beggars—in ink, in brush and later in charcoal. Yet nothing could be more different from Géricault's understanding of the nature of misery

Francisco Goya, *For Not Working* (*Pr. no trabajar*),
brush, watercolor, china ink on paper,
8⅛ × 5⅝ in. (20.6 × 14.4 cm), *c.* 1808–14.

in the early nineteenth century than Goya's version of it. This is partly due to the fact that mendicancy occupied a very contrasting position in the social and political ideology of Spain from the one it held in enlightened post-industrial England.

Certainly, a drawing like *For Not Working*, from Album C in the Prado, drawn with brush in gray and black wash, is, to cite Manuela Mena Marqués, "one of Goya's most expressive works on mendicancy."[11] In the same exhibition catalogue from 1989 she goes on to say that the man "wears picturesque rags, masterfully rendered by Goya's brush-strokes." In his right hand he holds a hat for alms, but he also reaches out with his left in order to make his plea sadder and more effective. His worldly goods are strapped on his back. "The facial expression— with its wide-open, almost bulging eyes, and open mouth—and the rank, matted hair make of this beggar a paradigm of absolute indigence, a living incarnation of hunger and extreme degradation."[12]

Yet the immense contrast in visual appearance between Goya and Géricault's representations of beggars is due not merely to individual characteristics of style and attitude. It has to do with the unbridgeable chasm between the social meanings of misery in two radically different countries: reactionary Spain, one of the most economically backward nations in Europe, and post-industrial England, the most economically and materially advanced. Goya, although he may have felt the deepest sympathy with the suffering victims of war or of the Inquisition, evidently felt little pity for those of economic injustice, an attitude he shared with many of his compatriots, even the most intellectually advanced. In the case of *For Not Working*, as Mena Marqués says, Goya does not appear to have felt compassion for this unappealing creature. His inscription is emphatic: the man has fallen into this sorry state "for not working," a severe judgment against the idleness in which many in Spain lived, ruining themselves and therefore the country. A universal theme among Goya's enlightened contemporaries was this repudiation of idleness and a similar denunciation of shameless begging.[13]

Pedro Rodríguez de Campomanes, an economic and educational reformer of the period, estimated that in 1775–77 there were 140,000 beggars in Spain. Although he backed reforms for the most miserable,

he nevertheless blamed the existence of so many beggars on what he regarded as "an innate Spanish disposition to idleness."[14] The poet and politician Juan Meléndez Valdés, in his *Legal Essays*, posthumously published in 1821—the very year Géricault created his images of the poor—condemned "the moral decadence and brutalization of beggars... without a country, without a fixed home, without the least obligation or care...prone to drink and a filthy slovenliness." For Meléndez Valdés, like his Spanish Enlightenment contemporaries, Goya among them, poverty that led to begging, lying, crime, and punishment brought about "the debasement and dishonor of the nation."[15] He went on to say that mendicancy was a plague that degraded and destroyed society, and declared that whoever sanctioned it with his injudicious alms had "failed in his civic duty, unwittingly fostering the physical and moral perversion of his fellow citizens." That poverty and especially mendicancy were more prevalent in Spain than elsewhere in Europe seemed to be substantiated by their being described as typical of the country in foreign travelers' accounts.[16] Spanish beggars' arrogance, underhandedness, and repertory of feigned diseases and pretended misfortunes, accompanied by distressing gestures, were frequently commented upon.

For Goya and his Enlightenment circle in Spain, beggary was dismissed as a time-dishonored occupation, looked on with scorn and derision. Of course, this variance in attitude is given visual expression in the difference in the style and structure of his representations. His beggars exist in no specific setting, in no time and place. It is not the socially nuanced details of poverty, but the brilliant virtuosity of Goya's pen or brush that we focus on as it moves effortlessly across the page, creating volume out of judiciously flicked light and shadow.

Even when Goya, in several of his drawings, captures the contours of crippled beggars in their carts—some created late in his life, in exile in Bordeaux—he conveys little sense of sympathy for these grotesque creatures and their conveyances. What he is interested in, apparently, is the ingenuity of their means of transportation, in one case, the employment of a large dog to pull the crude wheelchair. In no case does he express an interest in the contemporary environment in which the cripples live and struggle.[17]

Francisco Goya, *Beggars Who Get about on Their Own in Bordeaux*
(*Mendigos qe. se lleban solos en Bordeaux*), black chalk on paper,
7⅝ × 5½ in. (19.4 × 14 cm), 1824–27.

Francisco Goya, *That bag of flesh is his entire patrimony*
(*En el talego de carne lleba su patrimonio*), watercolor, china ink on paper,
8⅛ × 5⅝ in. (20.6 × 14.2 cm), 1808–14.

Francisco Goya, *I saw it in Paris* (*Yo lo he visto en Paris*),
drawing, 8⅛ × 5⅝ in. (20.6 × 14.2 cm), c. 1824–28.

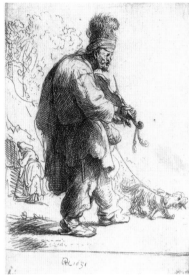

ABOVE LEFT
J. S. Müller, *The Blind Musician*, etching, 1741.

ABOVE RIGHT
Rembrandt van Rijn, *The Blind Fiddler*, etching, 1631.

In contrast, when Géricault focuses on a single figure in the English series, as he does in *The Piper*, the street musician's aura of melancholy isolation is intensified by the cityscape of misery and doom created by the incarcerating brick-walled setting, with its gridded materiality implying immanent destruction in its ruinous irregularities. Géricault's musician, unlike Goya's beggars, is a unique, dignified, even monumental, individual. His ragged clothing, each patch and rip patiently registered, points to a more prosperous past, lost in the turmoil of post-industrial upheaval. His sympathetic little dog, attached by a string, waits patiently and seems to be listening.

Géricault had plenty of precedents for his blind musician, in the many illustrated *Cries of London* and in other illustrated accounts of the itinerant poor folk who plied their wares or meager skills on the streets of the city.[18] In these popular collections, the poor and outcast

Théodore Géricault, *The Piper*, lithograph,
plate 1 in *Various Subjects Drawn from Life on Stone*
(London: Rodwell and Martin, 1821).

were always seen as alien creatures, picturesque at best, grotesque at worst. Even Rembrandt's etching, *The Blind Fiddler* (c. 1631), which comes closest to Géricault's *Piper* in its formal structure—the large, bulky protagonist accompanied by a small dog—defines the itinerant musician as exotic and unappealing rather than sympathetic, and the dog as an uncaring mongrel, placing them both in an unspecified rural background.

However, Géricault's *Piper*, like his drunken beggar, is entirely different from any other representation of the subject, contemporary or historical. In the words of Sean Shesgreen, author of *Images of the Outcast: The Urban Poor in the Cries of London*: "Géricault's 'Piper', showing a blind musician who plays unheard amidst a foggy wasteland of crumbling masonry, is tied to 'Pity the sorrows' in its oddly statuesque, even heroic portrayal of an aged man whose only link in life is to his tiny dog." Shesgreen continues with a more general estimation:

> Géricault's two lithographs embody a consciousness that is decisively modern, linked to defeat, failure of purpose, loss of meaning and oblivion—the drunk man is also on death's doorstep. Expressing their creator's astonishment at the misery of London's poor and "the black horror" of its slums in 1821, they take the depiction of back streets and back-street characters as far in the direction of anti-nostalgia as any artist does, perhaps as far as it can go and still pretend to aesthetic purpose or hope to win buyers among the respectable classes of the nineteenth century. The apocalyptic tone expressed in both lithographs' backgrounds, which reek of industrial ruin, is intensified by their technical monotony, boredom and incoherence.[19]

Well, yes and no. When you look at them in the original, they are, although without "personal flourish" or signature style, anything but boring—they are, on the contrary, rich in realist veracity, the lines and shadows intent on grasping and setting forth what is going on out there, not indulging in the self-concerned, self-aggrandizing personal touch of the artist. In fact, part of their power and pathos arises from the

fact that Géricault is deliberately reining in his prodigious virtuosity to create a style that recalls the stiffness and naivety of popular prints, as Courbet was to do a generation later. The so-called incoherence is part of the realist project, the refusal to make beautiful or coherent that which is neither. Shesgreen continues: "Even form itself seems threatened in these antipicturesque designs in which pictorial structure exposes fundamental assumptions about society and its urban outcasts. In these *willfully vapid* designs, the city and the human condition are in ruins, devoid of order and without purpose."[20]

"Willfully vapid…devoid of order…": we are moving into the space and structure of the documentary—or the work of Gustave Courbet and the realists later in the century. What was the work of the visual imagery of misery in the early nineteenth century, in the wake of the Industrial Revolution? What effects could an image have, and on what segments of the public? Could a crude, anonymous wood-engraving

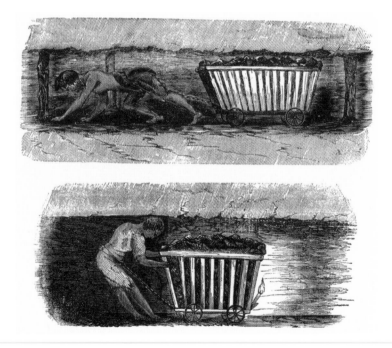

Children Pulling Coal from Children's Employment Commission,
First Report of the Commissioners, Mines, 1842. **103**

of children working in the mines bring about actual social and political change?[21] Well, in fact, the pictures published by Lord Ashley's Parliamentary Commission of 1842 did have an impact. Their very ineptitude, their crudeness, their total lack of either sentimentality or aesthetic quality made them all the more convincing as documentation of a sordid and painful truth. Obviously the work of nonprofessionals, and part of the witness accounts, these pictures and many written testimonials of child workers first appeared in the May 1842 *Report of the Inquiry into the Employment and Conditions of Children in the Mines and Manufactories*. The report made a sensation by exposing the degradation and hardship experienced by working children[22] and achieved the passage of laws forbidding children to work in the mines.

One might think of these illustrations as documentary photographs before the fact, visual testimony that rests on its pure indexicality for its power, even though drawn by the human hand, but a hand of such extreme modesty and "invisibility," so to speak, that it might as well be a lens. The drawings were done on the spot at the instigation, apparently, of Dr. Thomas Southwood Smith, one of the three commissioners. The effect, as Celina Fox relates, "was electric."[23] The *Times* declared that the woodcuts "were illustrative of the horrible and degrading labours to which too many of the unfortunate children employed in the coalmines appear to be subjected" and described the images in detail: "One of these woodcuts represents a child dragging a small wagon full of coal on all-fours, just like a beast of burden, and in a state of nudity!"[24] Of course, these were the early days of illustrated material in the mass media, enabled by wood-engraving and other technical advances in the printing and publishing industries.

In the case of nascent documentary photography, a lack of skill and elegant composition was seen as the stylistic guarantee of veracity and accuracy. Jacob Riis, the first prominent documentary photographer working at the end of the nineteenth and beginning of the twentieth century to record the terrible living conditions of recently arrived immigrants in New York City, was not a skilled photographer. He was a journalist and lecturer by profession and totally accidentally, starting in 1888, a photographer. Riis, as Bonnie Yochelson points out, "had no

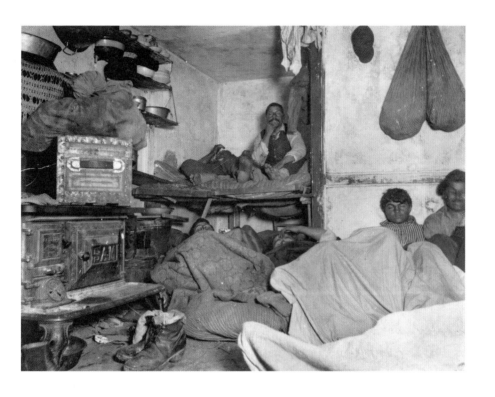

Jacob Riis, *Lodgers in Bayard Street Settlement, Five Cents a Spot*, 1889.
Gelatin silver print, 6⅗ × 5¾ in. (15.7 × 12 cm), printed 1957.

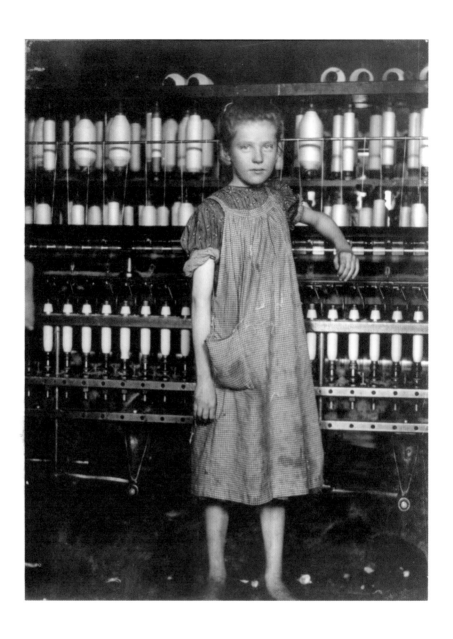

Lewis Hine, *Addie Card, 12 years old,*
anemic little spinner in North Pownal Cotton Mill,
Vermont, 1910.

aesthetic pretentions with his camera—'I had a use for it, and beyond that I never went,'" he declared. In fact, as this author points out, he took pictures for only a few years. Nevertheless, it was Riis who, "with the help of several other photographers, first used the new flash powder technology to make pictures of the slums."[25] The emphasis on dirt, grotesque expressions, mess and overcrowding, as well as the anti-aesthetic compositions produced by the flash, helped the cause of tenement reform.

In a work such as *Lodgers in Bayard Street Settlement, Five Cents a Spot* (1889), which provides a glimpse of lodgers in a crowded Bayard Street tenement, the primitive flash effect is much in evidence. This is the kind of illegal lodging house—charging five cents a spot—in which the huge influx of Italian immigrants to the Lower East Side's Mulberry Bend forced thousands of the homeless to sleep. This room and an adjoining one held fifteen men and women and a week-old baby. Riis was proud of his prowess as an activist, not as an artist. In his autobiography, he explained that he took the photo on a midnight expedition with the sanitary police who reported overcrowding: "When the report was submitted to the Health Board the next day, it did not make much of an impression—these things rarely do, put into mere words—until my negatives, still dripping from the dark-room, came to reinforce them. From them there was no appeal."[26] Collected in a book with a persuasive text, *How the Other Half Lives* (1890), Riis's forthright photographs gave effective aid to the cause of better, healthier housing for New York's immigrant population.

Lewis Hine, at the beginning of the twentieth century, fought against the injustices of child labor in mills and factories. He caught the dignity and pathos of his subjects, individualizing his portraits of the youthful child-laborers and contrasting their vulnerable humanity with the repetitive mechanical oppressiveness of the factory or mill interiors in which they were condemned to work. All his photographs have a purpose. Hine never degrades or patronizes his subjects: it is rather the system he critiques as he fights for poor children's right to childhood. With seeming objectivity—a kind of scientifically grounded intensity—he attempted to rouse the viewer

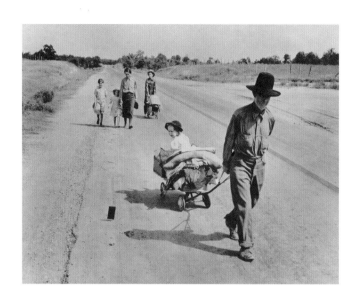

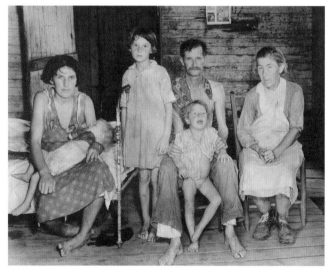

TOP
Dorothea Lange, *Family walking on highway, five children....*
Pittsburg County, Oklahoma..., 1938.

ABOVE
Walker Evans, *Sharecropper Bud Fields and his family at home.*
Hale County, Alabama, 1936.

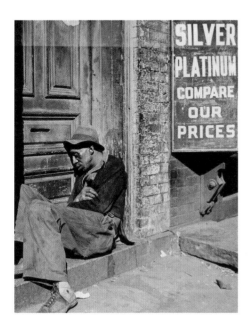 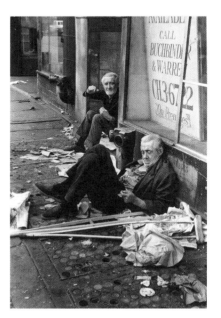

ABOVE LEFT
Rolf Tietgens, *Bum on Sidewalk*, 1938.

ABOVE RIGHT
Fred W. McDarrah, *On A Bowery Sidewalk: View of a pair of unidentified men,*
one asleep beside crutches, on a sidewalk in the Bowery neighborhood,
New York, New York, 1969.

to action, to the passage of child labor laws. Seeing his work, one is reminded of the cynical old verse: "The golf course lies so near the mill that nearly every day, the working children can look out and see the men at play."[27]

It was during the Great Depression of the 1930s that documentary practice reached its climax in the United States, with photographers such as Dorothea Lange, Margaret Bourke-White, Walker Evans and many other lesser-known FSA documentarists. Their purpose, in general, was to bear witness to the depredations brought about by the agricultural disasters of the period and the uprooting and poverty that resulted. Lange and her colleagues wished to arouse viewers to action with their images—political action in support of New Deal programs for the alleviation of mainly rural misery, and of the distress of migrant and displaced families. Their subjects were caught looking as miserable and yet as self-respecting as possible: no drunks, beggars or vagrants were encouraged to pose; the emphasis was on the family and the displacement and destruction of the family unit.

In the United States, after World War II, the documentary mode became increasingly popular, not necessarily as a weapon of reform—although it might still play that role—but as a way of selling magazines and books through displaying the scandals of poverty, exploitation and violence in the public media. Magazines such as *Look* and *Life*, with their striking, narrative picture stories, flourished. Uplift was not always the goal: sensationalism often was. The New York Bowery, with its drunken "bums," became a *thème à la mode*. The well-documented "Bowery Bum" conveyed a morality story to be sure, but could also be taken as a "picturesque" and titillating "slice of life" for the delectation of middle-class sensation seekers. Unlike the documentary photographs of the New Deal era, these post-war picture stories were not necessarily calls to action and support. Like the earlier *Cries of London*, Bowery documentaries were a condescending and objectionable form of the picturesque. Although some photographers, such as the members of the radical Photo League of New York, might add an ironic touch—a sign advertising precious metals—to a shot of a ragged drunk sleeping in a doorway,[28] most Bowery photography consisted of

anonymous and degrading images of abjection, marked with the grim specificity of the site itself. These figures are positioned as derelicts lying helplessly amid the garbage on the pavement, with the understood implication that they have fallen to the status of anonymous, human garbage. The Getty photo-image archive has a plentiful supply of this documentary topic. All of these photographs engage the trope of the drunken "bum," seated or lying unconscious on the doorstep or pavement before a dwelling or bar—the urban reject par excellence, just as Géricault's image of the London beggar had been more than a hundred years before, but with vastly different technical means and human implications...

With the work and texts of Martha Rosler, we confront the contemporary anti-documentary impulse at its most extreme, articulate and effective: no wonder this contemporary photographer and activist dismisses the documentary mode in no uncertain terms. We, the middle-class public, Rosler maintains, have been submerged in the documentary, positively wallowed in it—along with other media images—too long for them to have any material effect: "Sure, images that are meant to make an argument about social relations can 'work'. But the documentary that has so far been granted cultural legitimacy has no such argument to make. Its arguments have been twisted into generalizations about the condition of 'man,' which is by definition not susceptible to change through struggle." Speaking of *The Bowery in two inadequate descriptive systems* (overleaf), her own photo-text work of 1974–75, consisting of a series of forty-five black-and-white gelatin silver prints mounted on twenty-two black mount boards, she asserts: "This series keeps the visual reality of the Bowery architectural setting but substitutes the derogatory terms used to describe them for the living inhabitants of their streets",[29]—"There is a poetics of drunkenness here, a poetry out-of-prison. Adjectives and nouns built into metaphoric systems…applied to a particular state of being, a subculture of sorts, and the people in it."[30] She explains: "The photos represent a walk down the Bowery seen as arena and living space, as a commercial district in which…the derelict residents inhabit the small portal spaces between shop and street."[31]

Martha Rosler, *The Bowery in two inadequate descriptive systems*,
suite of 45 gelatin silver prints, each 10 × 22 in. (25.4 × 55.9 cm), 1974–75.

And she continues:

The photos here are radical metonymy, with a setting implying
the condition itself. I will not yield the material setting, though
certainly it explains nothing. The photographs confront the
shops squarely and they supply familiar urban reports. *They are
not reality newly viewed…*There is nothing new attempted in a
photographic style that was constructed in the 1930s when the
message itself was newly understood, differently embedded.
I am quoting words and images both.[32]

Well spoken, Martha Rosler; totally convincing. But are we willing
to give up on visual documentation of human beings without a mur-
mur? Must we reject the questionable pleasures of photographic
representation if we are to rid ourselves of its ideological trappings,
or is that throwing out the baby with the bathwater? Isn't Rosler, in a

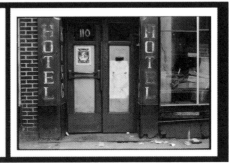

Details from *The Bowery in two inadequate descriptive systems.*

Eli Levin, *Bum*,
etching, *c.* 2010.

sense, preaching to the converted, to a small, sophisticated in-group
who know the recent history of photography, the art market and polit-
ical theory?

If we compare one of Martha Rosler's striking and thought-
provoking photo-texts with Géricault's *Pity the sorrows…* we are forced
to ask: which works best? And for what purpose? And when? And
for whom? Which intensifies the response to misery? Which, on the
contrary, makes us consider the issue of the *representation* of misery
itself? Is it possible even to represent misery in our media-saturated
age? Some people still think so and continue in the traditional mode of
misery representation: take for example the work of Eli Levin, a not-
so-young artist living in Santa Fe, who likens a drunken old man to
the refuse he lies on, in a quite up-to-date painted rendering of an old,
traditional socially conscious subject. This sort of representation works
better, perhaps, in the black-and-white print medium, like etching,
where the grimness, the documentary quality and the formal struc-
ture—a sort of Cubist and certainly aesthetically knowledgeable still
life in the background—emerge more forcefully.

REPRESENTING MISERY:
COURBET'S
BEGGAR WOMAN

Within the complex allegorical structure of Gustave Courbet's *Painter's Studio*[1] (1854–55, overleaf), the Irish beggar woman, seated on the ground to the left of the painter's canvas, constitutes not merely a dark note of negativity calling into question the painting's utopian promise but, rather, a negation of that promise as a whole. The poor woman—dark, indrawn, passive, a source of melancholy within the work as well as a reference to it outside the painting's boundaries—is both a sardonic memorial to Albrecht Dürer's historical *Melencolia I* (1513–14) and a return to the repressed (one might think of William Hogarth's drunken, degraded mother reaching for her snuffbox as her luckless infant slides off her lap in the British artist's moralizing allegory of 1751, *Gin Lane*). In other words, she is a figure undermining both the would-be harmony of Courbet's allegory and the image of art's triumph that dominates the center.

Because of the material specificity of Courbet's visual language, we are made aware, in the most substantial way possible, of allegory's alternate potential: to emphasize the signifier at the expense of the signified. Embodying in a single figure the convergence of gender and class oppressions, the Irish beggar woman becomes, for me, the central figure—the annihilation of Courbet's project in the *Painter's Studio*, not merely a warning about its difficulty. Figuring all that is inexplicable and irrational—female, poor, mother, passive, unproductive yet reproductive—she denies and negates all the male-dominated productive energy of the central portion and thus functions as the interrupter of

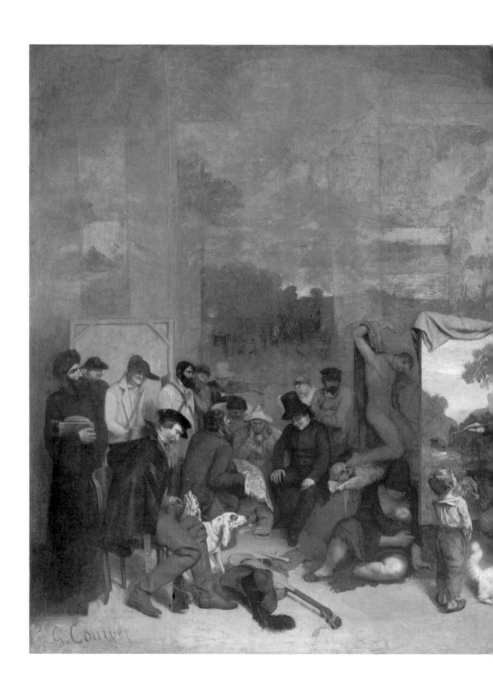

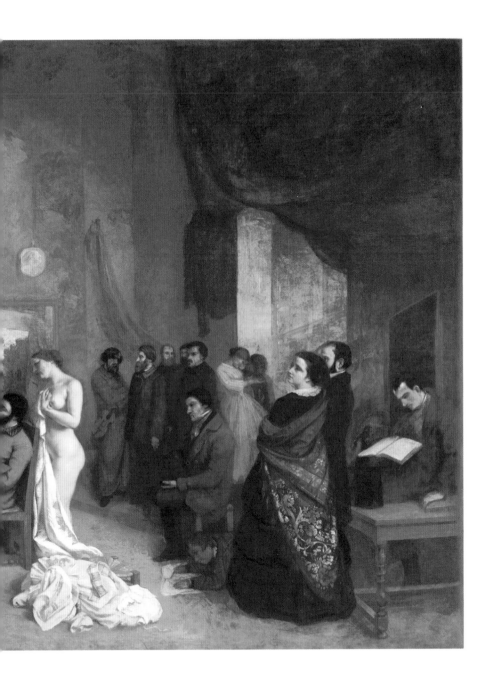

Gustave Courbet, *The Painter's Studio* (*L'Atelier du peintre*)
(after restoration), oil on canvas, 142⅛ × 235½ in. (361 × 598 cm), 1854–55.

Detail from *The Painter's Studio*.

the whole sententious message of progress, peace and reconciliation of the allegory as a whole. Bathed in ineluctable darkness, the Irishwoman resists the light of productive reason and constructive representation, that luminous and seductive aura surrounding the artist and his work.

Take her legs, for instance: bare, flabby, pale, unhealthy, yet not without a certain unexpected pearly sexual allure. The left one folds back in on itself, exposing its vulnerable fleshiness to the gaze of the viewer yet suggestively leading to more exciting, darker passages, areas doubly forbidden because this is a mother as well as an object of charity. The revealing of naked legs is, in the codes of nineteenth-century decorum, a signifier of degradation in a woman, an abandonment of self-respect. The implication of self-abasement is reiterated by the place where she sits: directly on the ground, so that the bare legs also figure in a secular, non-transcendent updating of the Madonna of Humility. But the legs of the Irishwoman signify powerfully within the text of the painting itself, as the antithesis of another pair: those of Courbet himself. Shapely, perky, aggressively thrust both forward toward the spectator and back into the pictorial space, the artist's legs are clad in elegant black-and-green-striped trousers. Picasso had a similar pair made for himself, symbolically assuming Courbet's role as the leader of artistic and social rebellion, as well as ostentatiously stepping into the pants of an overtly phallic master painter.

The difference between the legs of misery and lack and the legs of mastery and possession establishes the gender terms underpinning the meanings generated by the painting as a whole, within which the beggar woman evokes a dream of justice by personifying—or, more accurately, embodying—the manifest injustice of the existing social order represented by Courbet. That the figure had important implications for the artist is indicated by the fact that he referred to it several times, first in the form of what appears to be a sketch from life on a page from one of the Louvre Sketchbooks.[2] In a letter to his friend and supporter, Jules Champfleury, from Ornans, probably of November–December 1854, he identifies the seated woman with her baby as "an Irishwoman nursing a child," and adds: "The Irishwoman is another product from England. I encountered that woman in a London street. Her only clothing were

Gustave Courbet, *Figure Studies*,
Album Courbet Gustave -1- Folio 33 dessiné au recto.

[*sic*] a black straw hat, a green veil with holes, and a frayed black shawl beneath which she carried a naked child under her arm."[3]

Still later, a similar figure, this time in the guise of a gypsy woman or vagabond mother, shows up in *Charity of a Beggar at Ornans*, a work from 1868 that certainly goes back for its conception to 1854–55, when Courbet was concerned with the figure of the beggar woman and the theme of misery embodied in it. In the later picture, she makes her appearance as a ragged gypsy, crouched on the road with her baby, watching her equally ragged little son receiving a coin from a gaunt, disheveled beggar man in the foreground. The little boy seems to shield his nose from the beggar's rank odor. This work may indeed be, as Ségolène Le Men claims, part of Courbet's series of the open road,[4] but it seems to me equally well to constitute a link in the chain of Courbet's images engaging, in a variety of guises, with the dominating issue of misery and the indigent and marginalized human beings that bodied it forth. It was a theme that played an increasingly important role in the visual production of the later nineteenth century,

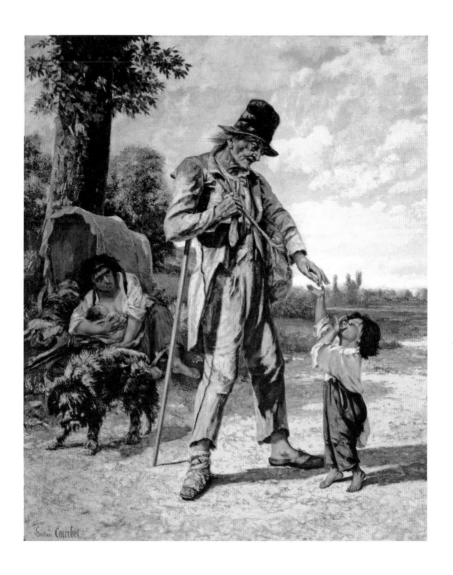

Gustave Courbet, *Charity of a Beggar at Ornans* (*L'Aumône d'un mendiant à Ornans*),
oil on canvas, 83 × 69 in. (210.9 × 175.3 cm), 1868.

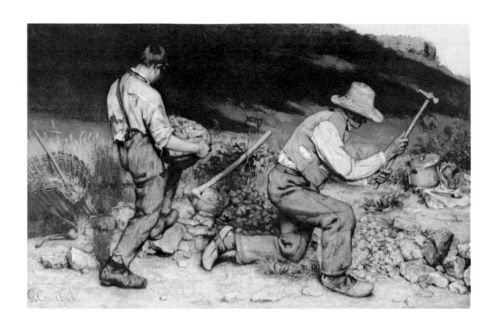

Gustave Courbet, *The Stonebreakers* (*Les Casseurs de pierres*),
oil on canvas, 62⅕ × 102 in. (159 × 259 cm), 1849.
Formerly held at Gemäldegalerie, Dresden (lost during the war).

although you would hardly know it from reading the texts of main-stream art history.

Courbet represented the theme of poverty—or, more accurately, the condition indicated by the French term *misère*[5]—several times dur-ing the course of his career. One of his earliest works, *The Stonebreakers* of 1849, is a powerful and self-conscious embodiment of misery itself and an indictment of the heartless social system that brings it about. Courbet himself was explicit about the nature of his subject, writing to Francis Wey and his wife about his experience on November 26, 1849: "I had taken our carriage to go to the Château of St. Denis to do a land-scape; near Maisières, I stopped to look at two men breaking stones on the road. It is rare to encounter such a complete expression of misery, so then and there the idea for a painting came to me." He continues with the same sense of unmediated engagement with his subject and the pressing social issue of which it is a manifestation:

On one side is an old man of seventy, bent over his work, his sledgehammer raised; his skin is burned by the sun, his face is shaded by a straw hat. His pants, of a coarse material, are patched everywhere, and inside his cracked clogs his heels show through socks that were once blue. On the other side is a young man, with dusty hair and a swarthy complexion. His filthy and tattered shirt reveals his sides and arms. A leather suspender holds up what is left of his trousers, and his muddy leather shoes show gaping holes on every side. The old man is kneeling; the young man is standing behind him energetically carrying a bas-ket of broken stones. Alas, in that [social] class that is how one begins and that is how one ends up.[6]

Courbet's generalizations about the failures of the social order come at the end of, and are the result of, his experience of concrete human bodies, their clothes, their complexions. And he goes on to generalize further about art and style, taking as his target one Louis Peisse, a critic, curator, and outspoken enemy of the artist, declaring: "Yes M. Peisse, we must drag art down from its pedestal. For too long

you have been making art that is pomaded and 'in good taste.' For too long, painters, even my contemporaries, have based their art on ideas and stereotypes."[7]

The importance of both the theme of *The Stonebreakers* and Courbet's realistic and detailed approach to it is underscored by a similar passage in a long and important letter from 1850 to Champfleury, in which Courbet carefully describes *The Stonebreakers* in even more exaggerated and colorful terms, emphasizing their poverty and misery. The picture, he declares, is composed "of two very pitiable figures: one is an old man, an old machine grown stiff with service and age." He then goes on to point out such abject details as "his drugget pants, which could stand by themselves," with a large patch, and his "worn blue socks" through which "one sees his heels in his cracked wooden clogs." The young man behind him is now specified as being about fifteen years of age, "suffering from scurvy." And, he adds: "Some dirty linen tatters are his shirt…His pants are held up by a leather suspender, and on his feet he has his father's old shoes, which have long since developed gaping holes on all sides." After describing the tools of their work and the landscape setting, he finishes, once more, with a testament to the veracity of his image—"I made up none of it, dear friend. I saw these people every day on my walk"—and concludes with the same generalization he made in his letter to the Weys: "In that station one ends up the same way as one begins."[8]

Interestingly enough, at the same time he was working on *The Stonebreakers*, and using what would appear to be a related model, Courbet created the little-known *The Vagabond* (1843–49), published in a monograph on the artist by Ségolène Le Men in 2008.[9] This ragged figure, roughly dressed and awkwardly posed, is seated, dozing, his head in his hand, by the side of the road, his ill-shod feet splayed out before him; his wanderer's stick and bundle lie on the rocky soil by his side. One might say that there is a curious affinity of both mood and posture between this resting vagabond and the seated Irish beggar woman of the *Studio*. The isolation, the marginality, and the sheer lack of minimal self-support or dignity are similar in both: both embody the condition of *misère* in their very being.

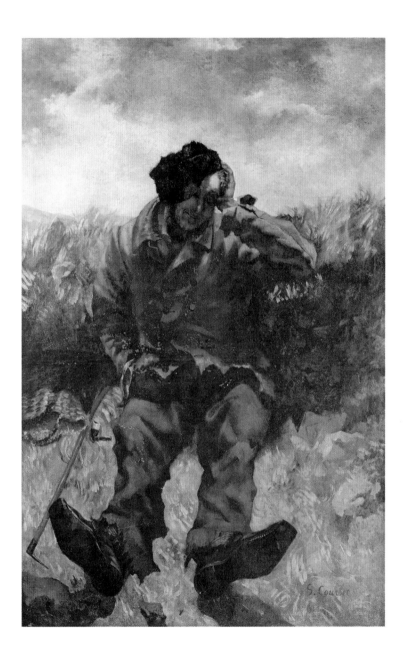

Gustave Courbet, *The Vagabond* (*Le Vagabond*),
oil on canvas, 44⅞ × 67½ in. (114 × 117.5 cm), 1843–49.

Gustave Courbet, *Young Ladies of the Village* (*Les Demoiselles de village*),
oil on canvas, 76¾ × 102¾ in. (194.9 × 261 cm), 1851–52.

Although it is a major work in what we might call Courbet's "*misère*
series," and one on which the artist expended considerable verbal as well
as visual energy, *The Stonebreakers*, like *The Vagabond* and the *Studio*'s
beggar woman, is far from being the only example of this theme with
which Courbet engaged. The monumental *Young Ladies of the Village*,
exhibited in the Salon of 1852 (purchased by the Comte de Morny, and
now in the Metropolitan Museum of Art, New York), definitely deals
with the theme of poverty, and its amelioration. The painting repre-
sents Courbet's three sisters—Zélie, Juliette and Zoé—as well as the
object of their benevolence, a ragged, barefooted little guardian of cat-
tle, in a peaceful pasture at the foot of the Roche de dix-heures, near
Ornans. Although Courbet, during this period immediately following
Louis Napoléon Bonaparte's coup d'état, was doubtless deeply upset
by the ruler's perfidy and the persecution and subsequent exile of his

old friend Max Buchon, his avowed intentions in *Young Ladies of the Village* were far from inflammatory. Nevertheless, the letter in which he describes the project to Champfleury has an undertone of sarcasm that belies his conciliatory phrases: "It is hard for me to tell you what I have done this year for the Exhibition. I am afraid of expressing myself badly. You will be a better judge than I when you see my painting. For one thing, I have misled my judges, I have put them on to new terrain: I have made something graceful [charming]. All they have been able to say until now will be useless."[10]

But is this really an image totally lacking in a political agenda, a harmless genre scene in a sunny landscape? Certainly, it was not received as "charming." Could the theme of charity—detached from religion and attached, specifically, to Courbet's sisters and his home territory—itself raise hackles, a specter of insubordination or even revolutionary socialism at this moment in French history? Diane Lesko, in her excellent article on the *Young Ladies of the Village*, points out that the painting may have been meant as a not-so-subtle reminder to Louis Napoléon that he had once been the author of a radical text on the subject of abject poverty, "The Extinction of Pauperism." Written in exile and first published in 1844, the future Emperor called for the alleviation of pauperism by means of "a communal system of sharing through the acquisition and rejuvenation of barren land, tilled by the poor and unemployed, who would move from the cities back to the country," with "instruction...[to] come from qualified bourgeois landholders."[11]

Although far from being a simple piece of political propaganda, the allegorical potential of the *Young Ladies of the Village* cannot be thrust aside as irrelevant to the painter's intentions and achievement. In an angry letter to the editor of *Le Messager de l'assemblée* of 1851, in which he mentions that he is working on the *Young Ladies of the Village*, Courbet declares his allegiance to the cause of social radicalism: "M. Garcin calls me 'the socialist painter.' I accept that title with pleasure. I am not only a socialist, but a democrat and a Republican as well—in a word, a partisan of all the revolution and above all a Realist. But this no longer concerns M. Garcin, as I wish to establish here, for 'Realist' means a sincere lover of the honest truth."[12] In emphasizing his

"Realist" affiliation along with his political ones, Courbet is referring both to the style, in the broadest sense, as well as the subject of his work. The *Young Ladies of the Village* bodies forth poverty and charity—the giving of bread to the needy, without either pathos or picturesque trappings—as an unsentimental everyday affair, concretely and materially represented in a setting that is the artist's own countryside: rough, rocky, unmanicured. It is a small-scale act of justice, a benevolent gesture bridging the chasm separating the comfortable from the needy, that has much larger implications.

Courbet returned to the theme of *misère* in the 1860s, with his *Poor Woman of the Village* of 1866, and, even more forcefully, in *Charity of a Beggar at Ornans*, exhibited in the Salon of 1868. The *Poor Woman* features a pathetic trio of the down and out in a bleak but ravishingly painted winter setting. The protagonist of the piece bears an enormous stack of faggots on her back and leads a recalcitrant goat on a string; before her trudges a little girl, ill-clad and bare handed, clutching a large loaf of country bread to her chest. The child seems to be the younger sister of the coherd in *Young Ladies of the Village*, inadequately garbed for the freezing atmosphere. Courbet is, in effect, demonstrating the shocking lack of resources of this small family: the woman forced to gather firewood—her only source of warmth; the goat her sole possession and means of nourishment, along with the bread, perhaps, a charitable gift from the commune or an individual. Where are they trudging, as the shadows lengthen and storm clouds threaten? Do they have a goal—a hut, however humble, to go to—or are they homeless as well as resourceless? In isolating their dark silhouettes against a background of icy landscape and snow-covered cottages, Courbet suggests this possibility—an extreme, and local, case of destitution.

The climactic painting of the *misère* series of the 1860s, however, is the monumental *Charity of a Beggar* of 1868, now in the Burrell Collection in Glasgow. In this work, "his last large protest canvas against the injustices of the world," according to Benedict Nicolson,[13] Courbet reverts to specific motifs related to his paintings of the mid-1850s: as noted earlier, the ragged gypsy woman with her baby seated in front of the dilapidated caravan in the background seems to be derived

Gustave Courbet, *Poor Woman of the Village* (*La Pauvresse de village*),
oil on canvas, 126 × 85 cm (49⅝ × 33⅜ in.), 1866.

from the same drawing in Courbet's Louvre Sketchbook that provided
the source for the beggar woman and her child in the *Painter's Studio*;
the little "gypsy" boy who receives the coin in the Glasgow painting
bears a striking resemblance to the admiring youth who stands to the
left of Courbet in the earlier work.

The figure of the gypsy woman had also appeared, albeit in a more
active and attractive guise, in *Gypsy Woman and Her Children* of 1853–54
(overleaf), striding through the countryside at sunset, her baby on her
back, accompanied by a little girl and an oddly dwarfish boy with a mon-
key perched on the hurdy-gurdy he carries on his back. Although clearly
defined as outsiders and wanderers, their weary journey marked by the
milestone on the road to the left, this strolling gypsy mother can hardly
be positioned as utterly abject, like her counterparts in *The Painter's
Studio* or. It is clear that this ambitious, unfinished painting was impor-
tant to Courbet. Large in scale, rich in detail and moving in its pathos,
it offers a startling contrast to the artist's almost contemporary *Peasants*

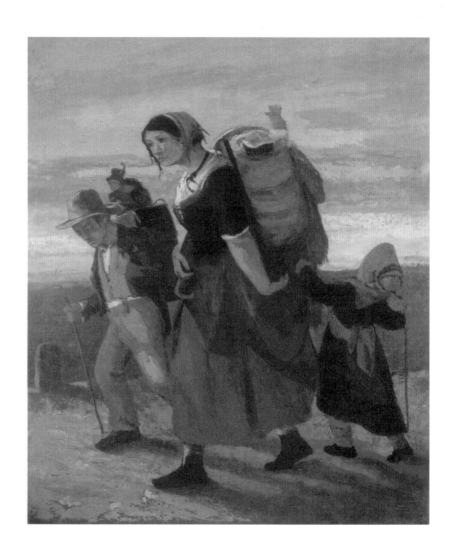

Gustave Courbet, *Gypsy Woman and Her Children*
(*La Bohémienne et ses enfants*), oil on canvas, 1853–54.

of *Flagey Returning from the Fair* (1850; reworked 1855), a monumental painting in which regional, personal and class identity is stressed. The characters represented in the latter work—the lead male figure on the horse (Courbet's father), the cattle women carrying baskets of produce on their backs, the odd man leading a pig on a string—are all rooted, regional and home-going. The ragged stragglers in the *Gypsy Woman and Her Children* are, on the contrary, rootless wanderers—tired, discouraged, strolling players—and the very epitome of *misère*. The milestone is the measure of their alienation from the social order as they go tramping along the anonymous highway.

Yet the central incident in *Charity of a Beggar* of the old mendicant presenting alms to a ragged urchin probably owes its inception to a theme that had inspired one of Courbet's major paintings, *The Meeting* of 1854 (overleaf)—the theme of the Wandering Jew.[14] This version of the legend, in one of its later and more socially critical metamorphoses, was published as a lithograph by Jean-Frédéric Wentzel in Wissembourg in 1860 and is discussed by Champfleury at considerable length in his essay on the subject. According to Champfleury, the basic essence of the legend of the Wandering Jew, its "allegory of charity," had finally been revealed in the Wissembourg broadside, where, in a cartouche interrupting the ornamental order at the base, the Jew is represented dropping a coin into the hat held out to him by a poor man. "For the first time," concludes Champfleury, "the print has shown the Wandering Jew as human. His role is finished. He is saved. Punished for his lack of charity, he is uplifted by charity."[15]

It must be noted that the theme of the poor dispensing charity to those who are even poorer is not restricted to the circle of Courbet or even to France itself. A year before Courbet painted *Charity of a Beggar at Ornans*, the Scottish genre painter and "poverty specialist" Thomas Faed (later admired by Vincent van Gogh) had exhibited a much more sentimental and appealing version of the theme, *The Poor, the Poor Man's Friend*, in which a poor but respectable fisherman's family is depicted giving alms to a ragged beggar and his child, who stand hesitantly at the left margin of the painting.[16] In this case, it is the much-debated question of the two classes of the poor—the working poor versus mendicant

Gustave Courbet, *The Meeting* (*La Rencontre*),
oil on canvas, 50¾ × 58⅝ in. (129 × 149 cm), 1854.

Thomas Faed, *The Poor, the Poor Man's Friend*,
oil on canvas, 16 × 24 in. (40.6 × 61 cm), 1867.

pauperdom—that is at stake.[17] Courbet's *Charity of a Beggar* embodies a much grimmer, less appealing vision of the situation. Both donor and receiver of charity are gritty, graceless and unlovely. The actual texture of the painting is rough and grimy. The physical decay of the beggar's body is called into allegorical play; the little receiver of charity puts up his hand to guard himself from the stench of the old man's unwashed body as the coin is dropped into his upraised hand; the beggar's foot is wrapped in a filthy bandage and he supports himself on a crutch; his face is lined, his stovepipe hat (a remnant of more prosperous times?) battered. If we consider this in some ways to be an older brother of the Wandering Jew figure represented earlier in *The Meeting*, we should note that every aspect of that earlier, more optimistic painting has been transformed in the later version: even the friendly, well-bred, and welcoming hound of the previous picture has been replaced by the snarling, mangy cur to the left of the beggar; the radically ungroomed gypsy woman stares up sullenly at the charitable deed taking place before her very eyes. The roadway in the foreground is bare and rocky. In its caricatural grotesqueness, *Charity of a Beggar* makes little attempt to capture the viewer's sympathy or compassion. On the contrary, like a political cartoon, it makes its point about poverty and marginality through hyper-realistic caricature. It does not demand sympathy as much as it calls for action.

If the figure of the beggar woman in the *Painter's Studio* with which I began this chapter may be understood in some way as a dream of justice shrouded in occluding darkness, then *Charity of a Beggar* is a call for justice in broad daylight, both unequivocal and unappealing, stressing the most unlovely aspects of misery as a universal social condition afflicting men and women, old and young, dogs as well as humans. Indeed, the theme of *misère* became increasingly popular as the nineteenth century progressed, with both advanced artists and conservative ones (and some who are harder to classify) turning to it in paintings, prints and, above all, political caricatures.

New terms evolve with new forms of representation: proletariat or *lumpenproletariat*, at the extreme end of the poverty scale. Gustave Doré, in his powerful black-and-white illustrations for *London: A Pilgrimage*,

published in 1872, creates a visual counterpart for Friedrich Engels's *Condition of the Working Classes in England* (1845), in a series of graphic vignettes of the various aspects of urban poverty and degradation. Both Édouard Manet and Camille Pissarro turn to the margins of society for their subjects: Manet's *Old Musician* (1862) displays the whole repertory of the theater of pauperdom—a little mother and child, ragged children, an old street violinist—and his *Ragpickers* (1869), if indebted to Diego Velázquez, shares Courbet's propensity for representing the poorest of the poor, albeit in an urban setting. Pissarro, in his highly political drawing series, *Les Turpitudes sociales* (1889–90), intended for his English nieces, condemns, in no uncertain terms, the entire capitalist system, mercilessly caricaturing bankers and brokers, sympathetically taking up the cause of the powerless and pauperized—especially the female victims of systemic poverty—with brutal graphism. His depictions of women sewing in sweatshops, a wife abused by her husband, a lost girl jumping off a bridge observed by blasé spectators, or a group of

Camille Pissarro, *Capital* from *Les Turpitudes sociales*,
pen and brown ink over graphite drawing on paper
pasted in an album, c. 1889–90.

women gassed by a leaky stove vividly convey the injustices lying at the heart of the economic and social system he condemns.

At almost the same time, Van Gogh works on his series of "orphan men," on the weavers and the potato eaters, treating these poor, unlovely and marginalized people in a deliberately awkward, expressive style of graphic intensity. Yet there is a difference between Courbet's relation to his paupers and powerless outcasts and those of the later vanguard, a palpable difference that speaks against any easy notion of continuity and "influence." For Manet, these themes are formally distanced, almost set in quotation marks, as part of a larger project of flattened pictorial irony. Pissarro, despite his committed anarchist politics, never published his *Les Turpitudes sociales*; they were meant for private enlightenment and delectation. Van Gogh turned away from his early dark-toned, earth-tinged focus on poverty and human disarray to more colorful and aesthetically self-conscious evocations of peasant life in the south of France, albeit with dark overtones.

There seems to be, in short, a direct antithesis between vanguard formal priorities and the representation of human misery with political implications. In this sense, Courbet's connection with his modernist "followers" must be examined more scrupulously and, indeed, called into question. The acceptance of "modernism" as the only viable way of confronting the contemporary world in all its diversity has been raised in the past few years, and rightly so. There is more than one way of being of one's times, of being modern. Courbet's beggar woman and his whole series of representations of the misery of the modern world and a concomitant call for justice within it form one of the most important of these "deviant" visions.

· 5 ·

FERNAND PELEZ:
MASTER OF MISERABLE
OLD MEN

If there is a single painter who might be denominated a specialist in the representation of *misère*, it would be Fernand Pelez, whose *The Homeless* appeared in the Salon of 1883. Scorned by supporters of avant-garde art and the Republican center, but admired by members of the far left and the far right, Pelez's style is a strange blend of detailed realism and emotional distance, despite the pathos of his subjects; his surfaces are thin and flat, tinged with mostly neutral color but sometimes enlivened by glowing detail.

Although it is not an overtly narrative painting, *Homeless* is rich in implications: the child in the background is foiled by announcements of a *grande fête*, peeling off the wall; a still life of displaced, worn-out objects to the right marks the family's meager household possessions; the hopelessness of the mother is mirrored in the grave expression of the oldest boy in the rear, while the younger children and the girl sleep wretchedly on the ground. This is a secular, updated version of the traditional Madonna of Humility, but it is deliberately divested of either spirituality or monumentality. In fact, this chilling and almost hypnotically hyper-naturalist maternal outcast—the anti-heroine of *Homeless*—seems, whether intentionally or not, to refer back to the Irish beggar woman in Courbet's *Painter's Studio*. Unlike the kitschy classicism of William-Adolphe Bouguereau's *Charity* of 1865, Pelez's family group lacks both idealization and sculptural elegance. Pelez's setting is definitely the *bas-fonds* of contemporary Paris, not the stage

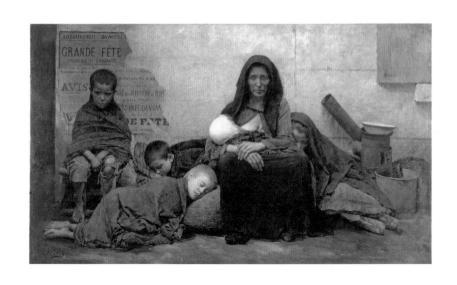

Fernand Pelez, *Homeless* (*Sans asile*),
oil on canvas, 53⅕ × 92⅞ in. (136 × 236 cm), 1883.

William-Adolphe Bouguereau, *Charity*,
oil on canvas, 48 × 60 in. (121.9 × 152.4 cm), 1865.

Fernand Pelez, *A Martyr: The Violet Seller*
(*Un martyr—le marchand de violettes*),
oil on canvas, 34¼ × 39⅜ in. (87 × 100 cm), 1885.

set of classical Rome. The detail of the mother's head gives you some notion of both the fineness of Pelez's drawing and the thinness of the paint, which nevertheless reveals itself as paint, no matter how different it may be from the revealed brushwork of the Impressionists or the thick slabs of pigment characteristic of some post-Impressionist facture.

Martyrized children were Pelez's specialty; in fact, one painting representing an impoverished street child was titled *A Martyr: The Violet Seller* when it appeared in the Salon of 1885. In this painting, the delicacy of the skin tones, the veil of dirt over the feet, the exhaustion implied by the open-mouthed face of the sleeping child, are set forth against a backdrop of almost abstract rectangular planes, playing against the tilt of the crude wooden tray dangling from the unconscious boy's neck. Pelez's images of children—exhausted, half-naked little ragamuffins—although they may hark back to the work of artists like Bartolomé Esteban Murillo in the seventeenth century, are nevertheless

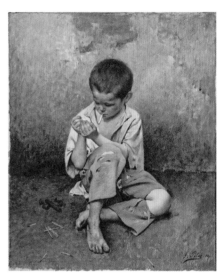

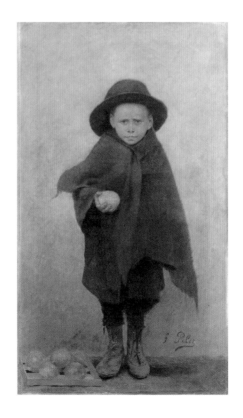

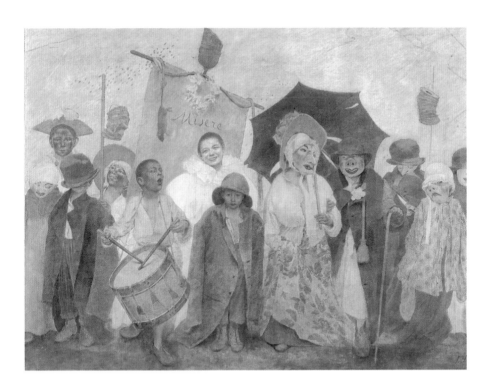

Bartolomé Esteban Murillo, *The Young Beggar* (*El joven mendigo*),
oil on canvas, 52¾ × 39⅜ in. (134 × 100 cm), c. 1645–50.

Fernand Pelez, *The First Cigarette* (*La première cigarette*),
oil on canvas, 37⅕ × 31⅛ in. (95.3 × 79.1 cm), c. 1880.

Fernand Pelez, *The Little Lemon Seller* (*Le petit marchand de citrons*),
oil on canvas, 47¼ × 27⅝ in. (120 × 70.3 cm), c. 1895–97.

Fernand Pelez, *The Vachalcade* (*La Vachalcade*),
oil on canvas, 74 × 96¼ in. (188 × 245 cm), c. 1896–1900.

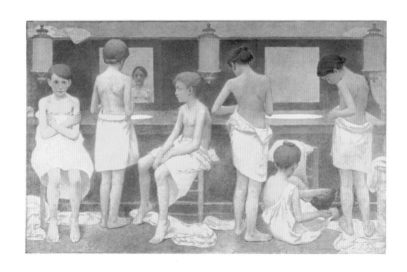

Fernand Pelez, *The little extras* (*Les petites figurantes*),
oil on canvas, 74 × 96½ in. (188 × 245 cm), 1911–13.

Fernand Pelez, *Little Dancer Putting on Her Tights in Front of the Mirror*
(*Danseuse mettant son collant devant un miroir*), black crayon on paper, 1905.

contemporary in their physiognomy and their attributes. Certainly the example of Murillo—in this case *The Young Beggar* in the Louvre—lies in the background of a Pelez work such as *The First Cigarette* of 1880. Yet Pelez deviates from the Murillian example in the contemporaneity of the type as well the perceivable dirtiness, the bareness of the setting and the inappropriateness of the action: surely this child is too young to be smoking! The background, in its muzzy gray impalpability, picks up the theme of smoke, incidentally. Pelez's representations of impoverished youth are perhaps epitomized in his *The Little Lemon Seller* (c. 1895–97), portraying a young boy in a ragged cloak and oversized derby (bowler hat), frowning worriedly at the spectator to whom he holds out a lemon.

The Vachalcade, created between 1896 and 1900, features the same little lemon-selling street urchin in a man-sized jacket amid a crowd of weirdly masked figures to the right and other vagrant children to the left, one in a Pierrot costume, smiling broadly against a banner bearing the inscription *Misère*, from which a dead rat dangles. The implications of the composition are both obvious and mysterious.[1] What is clear is that misery lies at the heart of the image, signified by the over-sized jacket and hat of the poor boy at the center of the canvas and made explicit by the word emblazoned on the banner. The fact that two of the street urchins are wearing over-sized clothing, clearly meant for grown men, not children, adds to the pathos of the representation, while the masks of the revelers to the right specify its grotesquery.

Pelez's depictions of young female *misérables*, mostly studies of dancers backstage, make a startling contrast to those of Degas. These extremely young dancers, shown partially nude in the course of getting dressed, are vulnerable in their nakedness or near-nakedness. Some of Pelez's images of these semi-nude little dancers are outright pathetic, as are the young girls represented in his *The little extras* (1911–13), which also serves as a compendium of various viewpoints of the undressed little figures. The most pitiful figures in the group include a female child on the far left, wrapped in a white towel, her arms crossed, her feet raised, staring at the spectator; or the seated figure of a little girl revealing her still-breastless torso and staring blankly into space. In *Little Dancer Putting on Her Tights in Front of the Mirror* (1905), a drawing in

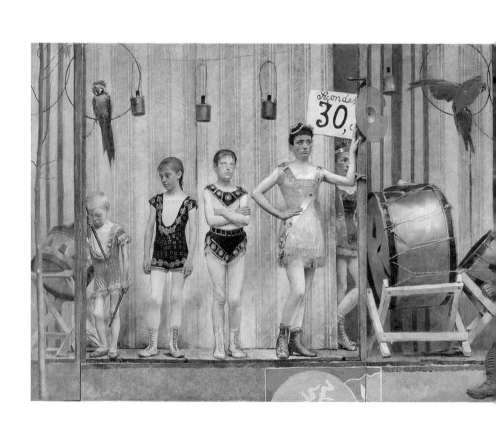

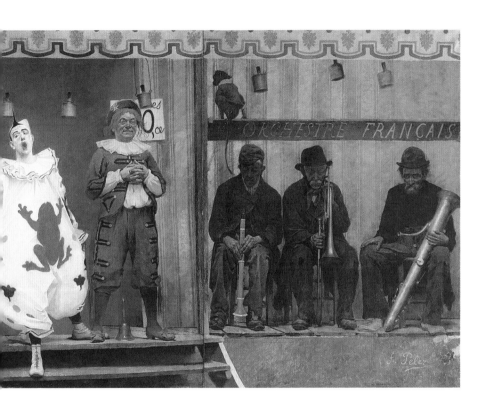

Fernand Pelez, *Grimaces and Misery: The Saltimbanques*
(*Grimaces et misère: les Saltimbanques*),
oil on canvas, 87⅜ × 240⅛ in. (222 × 610 cm), 1888.

black pencil with white accents, a young dancer is pulling up her stock-ings, her immature breasts facing toward the spectator, and her neck and shoulders reflected in the mirror behind her. All of Pelez's rep-resentations of young dancers are marked by a pathos and vulnerability quite different from Degas's understanding of similar subject matter. Pelez sees young ballet dancers as figures of *misère*, not as professional practitioners of a formalized set of movements.

Fernand Pelez's most ambitious completed work is the extraordinary *Grimaces and Misery: The Saltimbanques*, which made a considerable splash when it appeared in the Salon of 1888. A painting in five parts, it measures 222 × 610 centimeters and represents the ragged members of the *parade*, designed to attract spectators into the circus within the tent by displaying small samples of its offerings. The cast of characters ranges from small children to adolescents to a dwarf, with an open-mouthed clown occupying center-stage. The troupe leader stands next to them and the ragged old musicians are relegated to seats at the far right. Flatness is both part of the reality of the stage and inscribed in the painting's formal structure: the thinness of this pitiful, indeed *miserable*, realm of fantasy is literally transposed to the formal two-dimensional-ity of the cast spread across the picture plane. The children in their tawdry finery are exhausted and tearful: their pale, skinny legs bespeak unhealthiness; their poses are self-conscious, verging on the grotesque. This world of make-believe does not make us, the spectators, believe: on the contrary; in a way, Pelez has created an allegory of modern Paris as spectacle: gaudy, bespangled, effortfully entertaining but basically unconvincing, hollow, pathetic at its heart. Only the central, grimacing clown seems lively, in his white Pierrot outfit with a red frog jumping up his belly, but he is perhaps the saddest figure of all, revealing the hollowness and hopelessness of the whole operation—a fête of *misère*.

It is possible that Georges Seurat's *Circus Sideshow* of 1887–88 owes more than a little to the example of Pelez, as Robert Rosenblum astutely pointed out many years ago.[2] Yet despite the similarities of the subject—modern popular entertainment—there is little similarity in formal language or expressive quality. Seurat's painting is far more abstract, more decorative, less poignant than Pelez's, transforming the

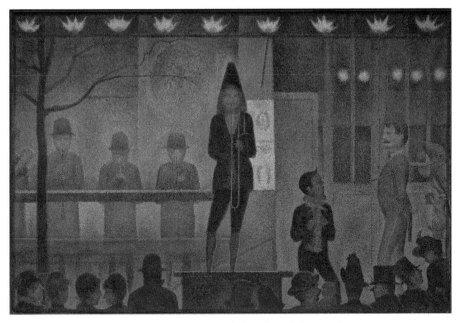

Georges Seurat, *Circus Sideshow (Parade de cirque)*,
oil on canvas, 39¼ × 59 in. (99.7 × 149.9 cm), 1887–88.

palpable misery of the event into a web of dazzling darkness, a two-dimensional *parade* of glittering, light-diffused multicolored dots.

After 1890, Pelez did not show in a Salon until his *Humanity!*, another ambitious, panoramic work, appeared in the Salon of 1896. This expansive park scene, created between 1894 and 1896, disappeared sometime after Pelez's posthumous studio exhibition of 1913 and now exists only in the form of a black-and-white photograph. The 390 × 800-centimeter canvas features diverse social groups ranging from the exhausted, ill-clad *misérables* of various ages and both sexes to the left, to the prosperous rosy-cheeked little girls with their nannies in the center to the well-dressed women flanking them and seated to the right. But this feminine figural group is thrown into relief by the contrast of the dark ill-dressed figure of an old working-class man at the right-hand margin, where he is ironically set in relief against the nude classical statue of a flute player. A strange, out-of-place figure of Christ hovers over

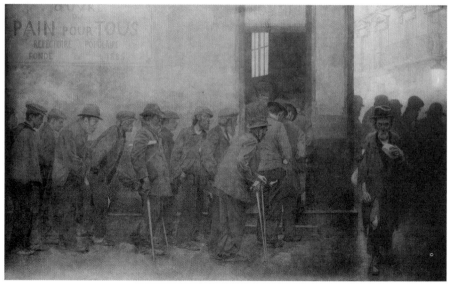

the center of the composition. It must be said that the inclusion of the Christ was severely criticized at the time of the exhibition.

Pelez's hyper-realistic, multi-paneled grisaille, *A Morsel of Bread*, completed in 1908, is the only work by Pelez to have been commissioned by the state. It depicted, almost without color, a group of ragged men of all ages hurrying to a charity that distributed bread to the needy. On the wall behind the breadline is inscribed "Oeuvre du pain pour tous, réfectoire populaire fondé en 1885."[3] Ten preparatory oil sketches from 1904 and a photograph of the finished painting in Pelez's studio in 1913 are the only record we have of the missing original. In that photographic reproduction (left), you can see the temporal progress of the parade of *misérables*: starting with the youngest at the end of the line on the left and the oldest at right, making contact with the spectator and clutching his bread in his hand. Again, the combination of formal flatness and scrupulous, detailed realism, devoid of narrative or emotional intensification, is striking: the variations of the dominant thematics of misery are readable in the unique physical appearance, clothing and posture of each of these figures. For some bourgeois critics of the time, it was just too much reality. As Émile Henriot wrote in *La Quinzaine artistique*, "there is mud in his brush… it is flat, it is gray, it is cold and dull."[4]

Pelez's representations of old men in the breadline are particularly poignant, constituting a variegated anthology of masculine impoverishment. The figures include a moving study of a bent creature with a sack and battered derby on his head; a hunched-over figure of a working-class man in torn trousers and scuffed slippers; a cripple with a crutch and a sack; and a middle-aged figure with hands in his pockets, staring blankly in front of him. Two of the most impressive figures in the series are seen three-quarters from the rear: one in clogs and a ragged jacket, the other supported by two canes, turned to one side as he enters the soup kitchen. This series of male paupers might be considered an urbanized reformulation of Courbet's *Charity of a Beggar* and of his Wandering Jew theme more generally.

Although the artist Jean-François Raffaëlli (1850–1924) has been called the "Meissonier of misery,"[5] one could, with greater accuracy,

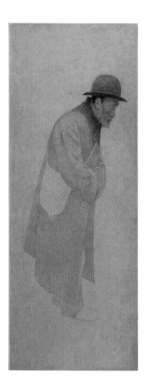
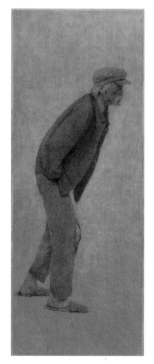
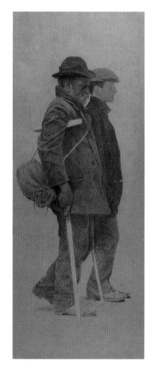

ABOVE LEFT
Fernand Pelez, *Old man wearing a derby hat*
(*Vieil homme au chapeau melon*),
study for *A Morsel of Bread*, oil on canvas, c. 1904.

ABOVE MIDDLE
Fernand Pelez, *Man leaning forward, with his hands in his pockets*
(*Homme avançant mains dans les poches*),
study for *A Morsel of Bread*, oil on canvas, c. 1904.

ABOVE RIGHT
Fernand Pelez, *Old man on crutches with a young man on his side*
(*Un homme marchant appuyé sur béquilles et un jeune homme en béret*),
study for *A Morsel of Bread*, oil on canvas, c. 1904.

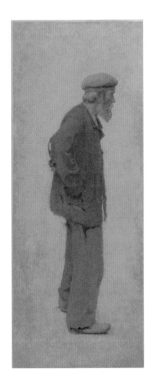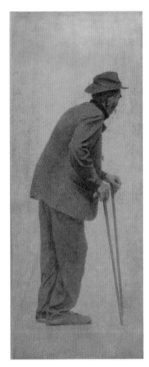

give this title to Fernand Pelez. One might also examine the evolution of the *misère* theme from Raffaëlli to Pelez, particularly in the case of the representation of miserable old men. In *The Absinthe Drinkers* (originally titled *Les Déclassés*) of 1881, Raffaëlli depicts impoverished old men literally living on the margins of society, occupying the *terrain vague* encircling Paris. Already, in the London lithographs of Géricault, it is clear that the figure of the poor old man—whether beggar, tramp or simply represented as sitting or walking—was a signifier of misery in the nineteenth century. The pathos of the figure of the miserable old man emerges from the sense that he had once been somebody or something, but had now fallen on hard times. Often such a figure bears vestiges of former prosperity—a top hat, a ragged, once elegant cloak, or shoes marred by visible holes—to remind the viewer that economic security is a frail and fleeting condition in post-industrial society. Van Gogh was deeply moved by the subject, and returned to the figure of the down-and-out old man many times during his career. Even Picasso, during his Blue Period, portrayed worn out, poor old men as embodiments of social marginality, in a work such as the *Old Guitarist* of 1903–04 (overleaf). The figure of the impoverished old man thus seems to be a primary signifier of misery for many artists at the turn of the century.

An investigation into nineteenth-century representations of poor old men would be incomplete without mention of Charles Paul Renouard (1845–1924), a once illustrious French documentary draftsman, who worked in England and Ireland and dealt with all kinds of subjects throughout the course of his long career.[6] Yet perhaps the realm Renouard preferred above all, at least during the 1880s, was that of the *misérables*, of the poor and oppressed, whether it be the working poor— miners, fishermen, artisans and factory workers; or the scrofulous inhabitants of the *bas-fonds*—ragpickers, drunkards, slum-dwellers. He also represented those existing on the margins of modern life, like the members of an anarchist club, or the down-and-out beggars of Ireland and England; or the lives of those too weak or helpless to make it on their own: the inmates of the Foundling Hospital, the prisons, the home for the Blind or the old soldiers at the Hôtel des Invalides.

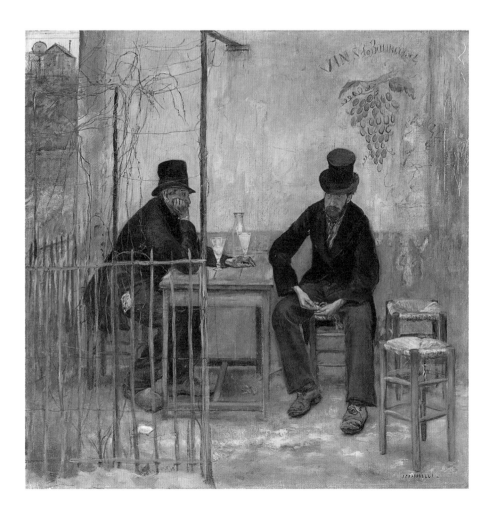

Jean-François Raffaëlli, *The Absinthe Drinkers* (*Les buveurs d'absinthe*),
oil on canvas, 74 × 74 in. (188 × 188 cm), *c.* 1881.

Pablo Picasso, *The Old Guitarist*,
oil on panel, 48⅜ × 32½ in. (122.9 × 82.6 cm), 1903–4.

Charles Paul Renouard, *Out of Work* (*Sans travail*),
pencil, ink and chalk, 12⅝ × 19 in. (322 × 48.3 cm), 1884.

Of all his works devoted to the representation of *misère*, Renouard's
Out of Work of 1884 best captures the image of the old, worn-out,
working-class man. An artwork in its own right, despite being a doc-
umentary drawing made for reproduction by wood-engraving, rich
in suggestive detail, it is an outstanding example of Renouard's work
of the 1880s. It is also a document of the crisis in the weaving indus-
try in Lyon in 1884, and, more generally, of the situation of manual
workers in the nineteenth century. *Out of Work* represents a scene
of enforced idleness in one of Lyon's domestic weaving workshops.
Executed in pencil, heightened with touches of black ink wash and
accents of black chalk and crayon, the drawing is rich in the kind of
graphic detail that seems to guarantee "documentary" authenticity.
The group illustrated would appear to consist of the "chef d'atelier"
and his family, with one of the "compagnons," the hired laborers who
assisted in the home workshops of the weavers, standing behind the
old man. The most impressive figure in the composition, the seated
elderly protagonist, is defined and contained almost haphazardly by

 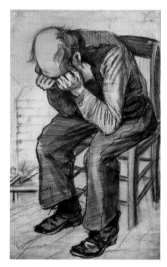

ABOVE LEFT
Vincent van Gogh, *Old Man with Top Hat
and Umbrella Under his Arm*, pencil on watercolor paper,
19⅛ × 9⅝ in. (48.5 × 24.6 cm), 1882.

ABOVE MIDDLE
Vincent van Gogh, *Old Man with Top Hat, Drinking Coffee*,
pencil, black lithographic crayon on watercolor paper,
19¼ × 11⅛ in. (49 × 28.3 cm), 1882.

ABOVE RIGHT
Vincent van Gogh, *Worn Out*,
pencil on paper, 19⅞ × 12½ in. (50.4 × 31.6 cm), 1882.

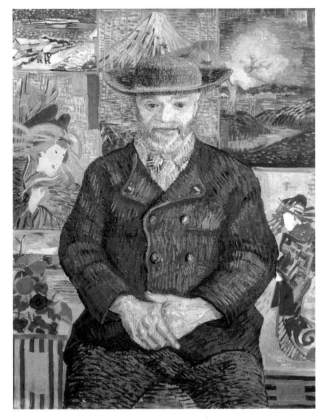

Vincent van Gogh, *Portrait of Père Tanguy*,
oil on canvas, 36½ × 29½ in. (92 × 75 cm), 1887.

the wavery hatching of the timber beams to the left, behind and to the right.

The central figure of the old, worn-out, working-class man so convincingly depicted by Renouard in *Out of Work* attracted Van Gogh for a long period of time and for diverse reasons. As early as 1882 at The Hague, Van Gogh embarked on his series of studies of "orphan men," "poor old fellows from the workhouse,"[7] figures which themselves recall Hubert von Herkomer's treatment of old men in *Sunday at Chelsea Hospital* (1871),[8] a work Van Gogh knew and admired. Van Gogh's "orphan men" culminated in the drawing *Worn Out* of November

1882,[9] which he transposed into a more heavily expressionist oil painting subtitled *At Eternity's Gate* in 1890.

But Renouard's old weaver is more self-controlled, less overtly despairing than Van Gogh's old men; he is in no sense an orphan but a family man, stoical and dignified in his bearing. A similar sense of long-suffering self-respect, a self-respect bordering on secular sanctity, dignified the aged men whom Van Gogh portrayed later in his career, figures like the *Père Tanguy* of 1887, the *Postman Joseph Roulin* of 1888, or *Patience Escalier, Shepherd of Provence* of the same year. Indeed, there is a remarkable affinity between Renouard's weaver in *Out of Work* and Van Gogh's color-merchant, *Père Tanguy*, although Van Gogh heightened the potential religious undertones of the image by choosing absolute rather than near frontality; suggesting Buddhistic affiliations in pose and setting; and playing up the halo-like propensities of the hat. Still, it is *Out of Work* that remains more naturally religious, as it were, an everyday icon of the modern man of sorrows, a man of sorrows distanced from his fellow sufferers by greater age and loss, seated in helpless dignity, twisted hands on wrinkled apron, respectfully regarded by his standing dependents, worshipers who in some way threaten their object of devotion, isolating him with claims of responsibility as much as they pay him homage.

The strength of Renouard's image, then, has to do with its secure and unlovely grasp, less sentimental than Van Gogh's "orphan men" and more explicit than his later portraits, of what it meant to be old, out of work, and helpless to change the situation. As such it is an image replete with painful contradictions: the family together but each member isolated; the space of work transformed into the arena of enforced idleness; the protective paternal figure the most overtly helpless of all. The very details underscore in their way the larger contradictions: the useless apron; the useless eyeglasses; above all, the useless hands, deprived of their rightful purpose.

CONCLUSION

There is a constant tension between the notion of modernity as inde-
pendence, stimulation, growth and progress and those who see it as
an experience of rootlessness, instability and alienation. Antagonism
to the Industrial Revolution—and to change in general—characterizes
the viewpoints of many historians and sociologists. Nostalgia for the
past, for small farms, for home production, for women working within
the bosom of the family, marks these critiques, which are themselves
based on a yearning for the past. If Eugène Buret and Friedrich Engels
saw the results of the Industrial Revolution as pain, deprivation and
misery for the working classes, there are other social critics who see
the coming of capitalism and the Industrial Revolution in a very differ-
ent light.

The historian Alison Light, for example, while admitting that
the working classes and poor had a terrible time of it, nevertheless
finds that the dreaded workhouse—however awful, demeaning and
mean-spirited—was often viewed as a temporary rather than a per-
manent condition; people would go in and come out when possible.[1]
A stay in the workhouse was rather like pawning meager possessions
on Saturday night and getting them back on Monday. Misery, in Light's
viewpoint, is a fluctuating rather than a permanent condition. Poverty
itself could be temporary. In the case of women's experience specif-
ically, there are sociologists and historians who feel the Industrial
Revolution actually improved women's condition. The economic his-
torian Ivy Pinchbeck, in her classic 1930 study *Women Workers and
the Industrial Revolution*, although acknowledging that women often
experienced difficulty and degradation, declares that the lives of many
women improved with the Industrial Revolution, which provided them
with more choices and greater independence.[2]

Marshall Berman also provides an alternative view of encroaching modernity, a more positive vision of the rejection of home and village, seeing them as places of restriction, superstition and stagnation, in contrast to the modern city, which offered its inhabitants the possibility of stimulation, growth and creativity. Berman, in his classic *All That Is Solid Melts Into Air*, presents the end of old dependencies and community constraints as a positive experience, and leaving the stultifying country for the stimulating cities as an exhilarating and exciting liberation. People fled to the cities not merely for work, but in pursuit of a more open future for themselves and their children. Indeed, the very idea that the future could be better or different is an integral part of post-Industrial Revolution ideology.

The most advanced artists of the later twentieth and early twenty-first centuries have been engaged with the idea of unrepresentability—the idea that since Auschwitz one cannot directly represent the horrors perpetrated upon humanity, or must, like the artist Doris Salcedo, present them indirectly. The artist's task in the nineteenth century was very different, indeed contrary: it was to find new and more accurate ways of representing outrage, oppression and misery, especially that misery brought about by the new social and economic conditions resulting directly or indirectly from the Industrial Revolution. Whether in the realm of high art or that of journalistic illustration, the task was to find visual means adequate to express the horrors of the Irish Famine, the degradation of underground workers in the mines, or the street scavengers of London—in a way that was convincing in its apparent accuracy, its sticking to the facts, and its refusal of conventional beauty or elegance.

The goal of the new representational mode was not aesthetic—indeed, aesthetic excellence was often considered a counter-indication of factuality. Crudeness, poor composition, imperfection of form—all were considered visual tokens of truthfulness and accuracy in what might be called the proto-documentary style of some nineteenth-century illustrators, who were transforming themselves into cameras before the fact. From the crude drawings published in the 1842 report of the Children's Employment Commission to the photographs of Jacob

Riis and afterward, stylistic excellence was often considered to be an impediment to truthful representation. An artist as proficient in the rhetoric of classical art and grand style as Géricault found inspiration in the streets of contemporary London and in the work of anonymous popular printmakers for his lithographs of 1821. Géricault records the evidence of contemporary London in striking detail, although the City itself is dissolved in a haze of smog in the background, as though the very source of misery must remain shrouded.

While the nineteenth century saw the construction of the documentary style to record new and contemporary forms of poverty, misery and degradation, some of the most advanced critical voices today reject the documentary style as belittling its subjects and degrading their condition. Martha Rosler, in her *The Bowery in two inadequate descriptive systems* (1974–75), makes the most forceful case against the documentary mode, insisting that the representation of, for example, Bowery bums degrades them whereas simply naming them—writing the words "bum," "derelict," "rummy" or "boozehound" in place of the visual representation—does not. Although Rosler may be quite correct in maintaining that the photographic representation of, for example, the homeless and dispossessed is outworn, ineffective and a powerless and imagistic cliché, it is unclear why representing the subject in verbal terms is more moral or has an ethical precedence over visual representation. This may be true of a clichéd subject like the drunk lying in the street, which goes right back to the nineteenth century (if not before) for its origins.

As a final footnote to the representation of misery in the nineteenth and twentieth centuries it is worth considering the work of Käthe Kollwitz, one of the only artists to grant agency to the poor and downtrodden: to represent them as politically charged actors on the stage of history, *misérables* making demands, resorting to physical violence to attain their goals in images of great power and originality. Both Kollwitz's *Weavers* series of 1898 and her *Peasant Wars* cycle of 1902–08 referred to actual historical occurrences in 1842 and 1526 respectively, and, at the same time, suggested contemporary political activism in Germany, when Kollwitz created her print cycles.

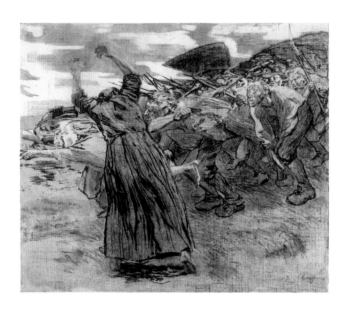

Of course, both series, like the events they commemorated, end tragically with the death of the strikers in the *Weavers* series, and the capture and eventual torture and execution of the peasant rebels. But the series as a whole constituted powerful and, at the same time, aesthetically sophisticated calls to action to the contemporary public of Kollwitz's day. Although the young artist, a socialist and feminist, was nominated for a gold medal in the annual exhibition of 1898 by none other than the renowned realist painter Adolph Menzel, the German Emperor refused to grant her the award. Kollwitz's art produced immediate political results!

NOTES

Introduction

1 Eugène Buret, *De la misère des classes laborieuses en Angleterre et en France; de la nature de la misère, de son existence, de ses effets, de ses causes, et de l'insuffisance des remèdes qu'on lui a opposés jusqu'ici; avec l'indication des moyens propres à en affranchir les sociétés* (1840; Paris, EDHIS, 1979). Buret's two-volume text is based on a research paper for which he received a prize of 2,500 francs from the French Academy of Moral and Political Sciences. I read further, of course, also consulting Engels's classic investigation of the condition of the working class in Manchester. There is no more memorable account of the human cost of the Industrial Revolution than Engels's description of the unspeakable conditions of existence suffered by the Manchester workers of his time.

2 "il est, chez les nations les plus avancées en civilisation et en richesse, un autre phénomène, bien aussi digne que le premier d'appeler l'attention des économistes, et qu'ils ont tous plus ou moins négligé." Cited in Buret, *De la misère* (1979), vol. 1, p. 13. All translations of Buret's text are mine.

3 "La misère, c'est la pauvreté moralement sentie. Il ne suffit pas que la sensibilité physique soit blessée par la souffrance, pour que nous reconnaissons la présence du fléau: il intéresse dans l'homme quelque chose de plus noble, de plus sensible encore que la peau et la chair; ses douloureuses atteintes pénètrent jusqu'à l'homme moral. A la différence de la pauvreté qui, comme nous allons le voir, ne frappe souvent que l'homme physique, la misère, et c'est là son caractère constant, frappe l'homme tout entier, dans son âme comme dans son corps. La misère est un phénomène de civilisation; elle suppose dans l'homme l'éveil et même déjà un développement avancé de la conscience." Ibid, p. 113.

4 "En Angleterre et en France, on trouve à côté de l'extrême opulence l'extrême dénûment, des populations entières, comme l'Irlande, réduites à l'agonie de la faim, aux dernières angoisses de la détresse physique et de la détresse morale; dans le centre même des foyers les plus actifs de l'industrie et du commerce, on voit des milliers d'êtres humains ramenés par le vice et la misère à l'état de barbarie." Cited in ibid., p. 14.

5 "La misère physique et morale, les crises dites commerciales, si fréquemment renouvelées qu'elles deviennent, on peut le dire, l'état permanent de l'industrie, les fraudes et falsifications mercantiles qui ont empoisonné presque toutes les branches du négoce, les fluctuations désastreuses dans la demande du travail, l'accroissement et l'agglomération des classes d'individus qui n'ont d'autre moyen d'existence que le salaire, souvent insuffisant, toujours incertain, d'autre industrie que la force brute, et, comme conséquence inévitable, les progrès du vice et du crime." Ibid., p. 29.

6 "…c'est le dénûment, la souffrance et l'humiliation qui résultent de privations forcées, à côté du sentiment d'un bien-être légitime, que l'on voit tout le monde se donner à peu de frais, ou que l'on s'est longtemps donné à soi-même." Cited in ibid., p. 112.

7 For an excellent, and exhaustive, examination of the problematics of representation, see *Representation: Cultural Representations and Signifying Practices,* ed. Stuart Hall (London, Sage in association with the Open University, 1997).

8 See the enchanting Fiennes–Žižek film, *The Pervert's Guide to Ideology* (2012), for confirmation of this assertion.

9 Steven Marcus, *Engels, Manchester, and the Working Class* (New York, Random House, 1972).

10 See Celina Fox, "The development of social reportage in English periodical illustration during the 1840s and early 1850s," *Past and Present*, 74 (February 1977), pp. 90–111.

11 I say this with hesitation; a global audience may still exist.

12 Victor Hugo, *Les Misérables*, trans. Lascelles Wraxall (Boston, Little, Brown, 1887), Vol. I, Book II, Chap. VII.

13 A colloquialism usually referring to the musical adaptations of *Les Misérables*.

14 Berman borrows his title from Marx and Engels's *Communist Manifesto* (1848).

15 Buret, *De la misère* (1840), p. 14.

16 Gustave Doré and William Blanchard Jerrold, *London: A Pilgrimage* (1872; New York, Dover Publications, 1970), p. 116.

17 The first three volumes of *London Labour and the London Poor; A Cyclopaedia of the Condition and Earnings of Those That Will Work, Those That Cannot Work, and Those That Will Not Work*, compiled from a series of articles Mayhew had written for the *Morning Chronicle*, were published in 1851. An "extra" fourth volume, co-written with three others, was published in 1861.

18 Many of Beard's illustrations for Mayhew's text were copied directly from daguerreotypes.

19 Marie Robert et al., *Splendeurs et misères: images de la prostitution, 1850–1910*, exhibition, Musée d'Orsay, Paris, September 22, 2015–January 17, 2016.

20 Jodi Hauptman et al., *Edgar Degas: A Strange New Beauty*, exhibition, Museum of Modern Art, New York, March 26–July 24, 2016.

21 "Géricault, Goya y la representación de la miseria tras la Revolución industrial," in Francisco Calvo Serraller et al., *El arte de la era romántica* (Madrid, Fundación Amigos del Museo del Prado; Barcelona, Galaxia Gutenberg, Círculo de Lectores, 2012), pp. 199–218.

22 See Sean Shesgreen, *Images of the Outcast: The Urban Poor in the Cries of London* (New Brunswick, NJ, Rutgers University Press, 2002; Manchester University Press, 2002) for one of the best accounts of this phenomenon.

23 "Courbet and the representation of 'Misère': a dream of justice," in *Courbet: A Dream of Modern Art*, eds Klaus Herding and Max Hollein, exh. cat. (Ostfildern, Hatje Cantz, 2010), pp. 76–83. Another version of this lecture was published in the *Documenta 14* magazine under the title "Representing misery: Courbet's beggar woman": www.documenta14.de/en/south/3_representing_misery_courbet_s_beggar_woman.

24 Robert Rosenblum spotted Fernand Pelez years ago, when he wrote about *Grimaces and Misery* as a possible source for Seurat's much better known *Circus Sideshow*. See "Fernand Pelez, or The Other Side of the Post-Impressionist Coin," in *Art, the Ape of Nature: Studies in Honor of H. W. Janson*, eds Moshe Barasch and Lucy Freeman Sandler (New York, Harry N. Abrams, 1981), pp. 707–18, and Ch. 5, note 2, for further discussion of the relationship between these two works.

25 See Marshall Berman, *All That Is Solid Melts Into Air* (New York, Simon & Schuster, 1982; London, Verso, 1983).

26 Pierre Bourdieu (under the direction of), *La misère du monde* (Paris, Éditions du Seuil, 1993).

Chapter 1

1 Eugène Buret, *De la misère des classes laborieuses en Angleterre et en France; de la nature de la misère, de son existence, de ses effets, de ses causes, et de l'insuffisance des remèdes qu'on lui a opposés jusqu'ici; avec l'indication des moyens propres à en affranchir les sociétés* (1840; Paris, EDHIS, 1979), vol. 1, pp. 202–7.

2 "… est le domaine privilégié de la misère: cette île, aussi fertile par elle-même que l'Angleterre, est habitée par un peuple de meurt de faim. Et ce peuple n'a pas besoin d'autres aliments que la pomme de terre, et la pire espèce de pomme de terre, le grossier et spongieux lumper. Et il meurt de faim!" in ibid., p. 202.

3 "Il n'y a pas de degré possible dans la misère en Irlande. Cette nation est misérable à tel point qu'elle ne connaît plus qu'un seul besoin: la faim; qu'elle n'a plus qu'un seul genre d'aisance: manger assez pour vivre. Tous ceux qui sont pauvres le sont également et de la même manière; ils ont peine à se procurer les trois livres de lumper nécessaires pour apaiser chaque jour les besoins du viscère digestif." Ibid., p. 203.

4 Gustave de Beaumont, *L'Irlande sociale, politique et religieuse* (Paris, 1839), ed. and trans. W. C. Taylor, *Ireland–Social, Political and Religious* (London, 1839; Cambridge, Mass., The Belknap Press of Harvard University Press, 2006).

5 There are numerous texts devoted to the Irish Potato Famine. See Cecil Woodham-Smith, *The Great Hunger: Ireland 1845–1849* (London, Hamish Hamilton, 1962; New York,

Harper & Row, 1962), Cormac Ó Gráda, *Black '47 and Beyond: The Great Irish Famine in History, Economy, and Memory* (Princeton, NJ, Princeton University Press, 2000), or Colm Tóibín and Diarmaid Ferriter, *The Irish Famine: A Documentary* (London, Profile Books, 2004).

6 The American cultural anthropologist.

7 Tom Garvin and Andreas Hess, "Introduction: Tyranny in Ireland?", in *L'Irlande sociale, politique et religieuse*, 2006, pp. XIV–XV, n. 11.

8 Ibid., p. XV.

9 Garvin and Hess acknowledge the similarities in "scheme and structure" between Beaumont's *L'Irlande* and *Democracy in America* written by Beaumont's close friend Alexis de Tocqueville. Beaumont accompanied Tocqueville on his 1831 tour of America and co-wrote the report on their findings: *On the Penitentiary System of the United States and Its Application to France* (Philadelphia, Carey, 1833).

10 Beaumont, *L'Irlande*, p. 131.

11 James Mahony, "Sketches in the West of Ireland," *Illustrated London News*, 10:250 (February 13, 1847), p. 100.

12 Cited in Margaret Kelleher, *The Feminization of Famine: Expressions of the Inexpressible?* (Durham, NC, Duke University Press, 1997), p. 17.

13 Mahony, "Sketches in the West of Ireland," *Illustrated London News*, 10:251 (February 20, 1847), p. 116.

14 For current caricatures see Michael de Nie, *The Eternal Paddy: Irish Identity and the British Press, 1798–1882* (Madison, WI, University of Wisconsin Press, 2004), *passim*.

15 Kelleher, 1997, p. 25.

16 Mahony, "The Condition of Ireland," *Illustrated London News*, 15:404 (December 22, 1849), p. 405.

17 Ibid., p. 406.

18 Ibid.

19 Mahony, *Illustrated London News*, 10:250 (February 13, 1847), p. 100.

20 Kelleher, 1997, pp. 22–23.

21 Luke Gibbons, *Limits of the Visible: Representing the Great Hunger* (Cork, Cork University Press, 2015), p. 11.

22 Ibid., p. 12.

23 Mahony, *Illustrated London News*, 10:251 (February 20, 1847).

24 This was the most commonly used term for Famine-era evictions, also referred to as de-housing.

25 Margaret Crawford, "The Great Irish Famine 1845–9: Images versus reality in Ireland," in *Ireland: Art into History*, eds Brian P. Kennedy and Raymond Gillespie, (Dublin, Town House, 1994), pp. 83–84.

26 Ibid., p. 84.

27 Ewa Lajer-Burcharth and Beate Söntgen (eds), *Interiors and Interiority* (Berlin, Walter De Gruyter, 2016), p. 1.

28 Ibid., p. 2.

29 Ibid.

30 Ibid., p. 3.

31 "La misère, c'est la pauvreté moralement sentie…[elle] frappe l'homme tout entier, dans son âme comme dans son corps", Buret, vol. 1, p. 113.

32 Nevertheless, a traditional bronze statue entitled *The Three Servicemen* was added in 1984 to complement Maya Lin's wall.

33 Margaret Kelleher, "Hunger and history: monuments to the Great Irish Famine," *Textual Practice*, 16:2 (2002), pp. 249–76 at p. 264.

34 Ibid.

35 Ibid.

36 Battery Park City Irish Hunger Memorial brochure.

37 Simon Schama, "A patch of earth," *New Yorker*, August 19, 2002.

38 Ibid.

Chapter 2

1 "Le fait le plus remarquable et le plus triste en même temps qui ressorte de ce tableau, c'est le nombre disproportionné des femmes indigentes comparé à celui des hommes. Il est presque généralement une fois plus élevé. Dans notre société, la femme a beaucoup plus de peine à vivre que l'homme, bien qu'elle ait moins de besoins, et des habitudes généralement plus sobres. Nous ne voulons point faire de déclamation sentimentale, mais un tel résultat n'est-il pas déplorable? La condition de la femme pauvre, de la femme ouvrière, est affreuse." Cited in

Eugène Buret, *De la misère des classes laborieuses en Angleterre et en France, France; de la nature de la misère, de son existence, de ses effets, de ses causes, et de l'insuffisance des remèdes qu'on lui a opposés jusqu'ici; avec l'indication des moyens propres à en affranchir les sociétés* (1840; Paris, EDHIS, 1979), vol. 1, p. 268.

2 "Certaines industries semblent organisées tout exprès pour faire de la prostitution une nécessité. Ce sont celles qui sont su jettes à des chômages périodiques un peu prolongés…Quand la manufacture refuse le travail qui donne le pain, on s'adresse à la prostitution pour l'obtenir!" Cited in Buret, *De la misère* (1979), vol. 2, p. 13.

3 *De la prostitution dans la ville de Paris, considérée sous le rapport de l'hygiène publique, de la morale et de l'administration* (Paris, J.-B. Baillière, 1836).

4 "La prostitution devient à son tour une cause de misère. Il n'y a pas dans le monde de condition plus misérable que celle des filles exploitées par les dames de maison, qui traitent ces malheureuses créatures comme de véritables bêtes de somme dont le corps doit fatiguer à leur profit, en échange de la nourriture." Buret, *De la misère* (1979), vol. 2, pp. 255–56.

5 Charles Bernheimer's *Figures of Ill Repute: Representing Prostitution in Nineteenth-Century France* (Cambridge, Mass., Harvard University Press, 1989; new edn, Durham, NC, Duke University Press, 1997) still remains the most acute, perceptive and suggestive source on this subject.

6 The most thoroughgoing, yet still inconclusive, study of syphilis and venereal disease in the nineteenth and twentieth centuries, especially of its effects on artists—Schubert, Schumann, Maupassant, Flaubert, Van Gogh, etc.—remains Deborah Hayden, *Pox: Genius, Madness, and the Mysteries of Syphilis* (New York, Basic Books, 2003).

7 Bernheimer, p. 3. For the latter, see Abigail Solomon-Godeau's now classic article: "The legs of the Countess," *October*, 39 (Winter 1986), pp. 65–108.

8 Tristan insists on her personal presence as a witness to the scene. See Flora Tristan [Flore Celestine Therese Henriette Tristan y Moscozo], *Flora Tristan's London Journal: A Survey of London Life in the 1830s (Promenades dans Londres)*, trans. Dennis Palmer and Giselle Pincetl (London, George Pior, 1980; Cambridge, Mass., Charles River Books, 1980), p. 78 and n. 1. This passage recapitulates that in Linda Nochlin, *Courbet* (London and New York, Thames & Hudson, 2007), p. 209.

9 Marie Robert et al. *Splendeurs et misères: images de la prostitution, 1850–1910*, exhibition, Musée d'Orsay, Paris, September 22, 2015–January 17, 2016 (exh. cat., Paris, Flammarion, 2015).

10 Jodi Hauptman et al., *Edgar Degas: A Strange New Beauty*, exhibition, Museum of Modern Art, New York, March 26–July 24, 2016 (exh. cat., New York, Museum of Modern Art, 2016).

11 Among the categories in Warburg's image atlas, *Mnemosyne*, was the *Nympha*, the figure of the young woman in a flowing garment, who appears to be in movement.

12 *L'Assommoir* first appeared in 1876 as a serial in *Le Bien Public* and was subsequently published as a book in 1877. The illustrated edition was published by C. Marpon et E. Flammarion (Paris) in 1878.

13 Émile Bayard's *Cosette* and Adrien Marie's *Cosette Under the Table* were both included in the 1887 English translation of *Les Misérables* (Victor Hugo, *Les Misérables*, trans. Isabel F. Hapgood, New York, Thomas Y. Cromwell & Co., 1887), alongside illustrations by other artists.

14 Cosette, in *Les Misérables*, later goes on to a better life, marrying her sweetheart, Marius: but that is later, and, given the vast sweep of Hugo's narrative—much later.

Chapter 3

1 Théodore Géricault, "Pity the sorrows of a poor old man!…", 1821. Lithograph (Loÿs Delteil 31.IFF23). Paris, Bibliothèque Nationale de France, Estampes et Photographies, Reserve DC-141 (B)-Fol.

2 The verse, better known as a children's song, goes back to the eighteenth century. It begins: "Pity the sorrows of a poor old man! Whose trembling limbs have borne him to your door…"

3 "'Peu de temps après son arrivée en Angleterre,'—a écrit Charles Clément— 'Géricault s'était mis en rapport arec Hullmandel, le meilleur imprimeur-lithographe de Londres, et avec les éditeurs Rodwell et Martin, chez qui il publia, dans les premiers mois de 1821, les douze pièces (treize en comptant le titre) qui forment la suite de grandes lithographies anglaises. Ces estampes,' assure Ch. Clément, 'eurent beaucoup de succès: mais elles furent causées, de divers mécomptes pour Géricault…'" See Charles Clément, *Géricault* (Paris, 1879), as cited in Loÿs Delteil, *Le Peintre-graveur Illustré (XIXe et XXe siècles)*, vol. 18 (Paris, Chez l'auteu, 1924), G, 29, 1.
4 See Régis Michel, *Géricault: l'invention du réel* (Paris, Gallimard, 1992), pp. 98–99.
5 Régis Michel, *Géricault*, exh. cat. (Paris, Galeries Nationales du Grand Palais, 1991), p. 202.
6 Théodore Géricault, letter to Horace Vernet, cited in Lorenz Eitner, *Géricault: His Life and Work* (London, Orbis, 1983; Ithaca, NY, Cornell University Press, 1983), p. 218.
7 Régis Michel, *Géricault* (1991), p. 202.
8 See Gustave Doré and Blanchard Jerrold, *London: A Pilgrimage* (London, 1872). For Doré's famous illustrations, see *passim*.
9 *Les Boueux*, 1823 (Delteil, 75.IFF32). This lithograph was not part of Géricault's English series.
10 *La Palalytiique [sic], a Paraleytic [sic] Woman* (Delteil, 38). See my article (Linda Nochlin, "Géricault, or the absence of women," in *Géricault* [Louvre: conférences et colloques], ed. Régis Michel, Paris, 1996, vol. 1, pp. 403–21), in which I speculate about this subject and many others.
11 *Pr.[sic] no trabajar (For Not Working)*. Album C, page 1, *c*. 1803–21. Brush with wash. Museo del Prado, Madrid. See Alfonso E. Pérez Sánchez and Eleanor A. Sayre (eds), *Goya and the Spirit of Enlightenment,* exh. cat. (Boston, Bulfinch Press, 1989), pp. 172–74.
12 Ibid., p. 172.
13 Ibid.
14 Cited in Pérez Sánchez and Sayre (1989), p. 173.
15 Ibid., p. 173.
16 Ibid., p. 174.

17 For reproductions of these drawings of beggars in crude wheeled carts, from Albums C and G, see Sánchez and Sayre, (1989), no. 167, *Beggars Who Get about on Their Own in Bordeaux*, Album G, p. 29, 1824–28, and figs. 1 and 2 from Album G, p. 31 and Album C, p. 35, respectively; pp. 372–73 Pierre Gassier, *Francisco Goya: Drawings. The Complete Albums*, trans. J. Emmons and R. Allen (New York, Praeger, 1973).
18 See Sean Shesgreen, *Images of the Outcast: The Urban Poor in the Cries of London* (New Brunswick, NJ, Rutgers University Press, 2002; Manchester, Manchester University Press, 2002), for one of the best accounts of this phenomenon. Also see Lynn R. Matteson, "Géricault and English 'Street Cries,'" *Apollo*, 106 (October 1977), pp. 304–6.
19 Ibid., pp. 190–91.
20 Ibid., p. 191. The italics are mine.
21 See Celina Fox, "The development of social reportage in English periodical illustration during the 1840s and early 1850s," *Past and Present*, 74 (February 1977), fig. 1 for a reproduction of the image in question. It is titled *Children's Employment Commission: First Report of the Commissioners, Mines. Appendix, Pt. II, Report and Evidence from Sub-Commissioners*, Parliamentary Papers, 1842 [382], XVII, p. 65.
22 Celina Fox, "The development of social reportage" (February 1977), p. 94.
23 Ibid., p. 95.
24 Bonnie Yochelson and Daniel Czitrom, *Rediscovering Jacob Riis: Exposure Journalism and Photography in Turn-of-the-Century New York* (New York, New Press, 2007), p. 86.
25 Ibid., p. 140.
26 See Kate Sampsell-Willmann, *Lewis Hine as Social Critic* (Jackson, MS, University Press of Mississippi, 2009).
27 See, for example, Rolf Tietgens, *Untitled, c.* 1938, in *The Radical Camera: New York's Photo League, 1936–1951*, exh. cat., eds Mason Klein and Catherine Evans (New Haven and London, Yale University Press, 2011), plate 39, p. 126.
28 Martha Rosler, *Decoys and Disruptions: Selected Writings, 1975–2001* (Cambridge, Mass., MIT Press, 2004), p. 193.
29 Ibid., p. 194.

30 Ibid., pp. 194–95.
31 Ibid., p. 195.

Chapter 4

1 The painting is subtitled "A real allegory summing up seven years of my artistic and moral life."
2 Sketchbook RF, 9105, fol. 33r, Paris, Musée du Louvre, Cabinet des Arts Graphiques.
3 Letter to Champfleury, Ornans, November–December 1854, in *Letters of Gustave Courbet*, ed. and trans. Petra ten-Doesschate Chu (Chicago, University of Chicago Press, 1992), Letter 54–8, pp. 131–33. The emendation is mine.
4 Ségolène Le Men, *Courbet*, trans. D. Dusinberre et al. (New York, Abbeville Press, 2008), pp. 156ff.
5 See the distinction between poverty and *misère* made by St. Thomas Aquinas, for whom poverty represented the lack of superfluity, whereas misery signified the lack of the necessary. See the long discussion of *misère* in *Encyclopédie de L'Agora*: Misère, http://agora.qc.ca/dossiers/misere. For the English terminology of poverty in the broadest sense, see Gertrude Himmelfarb, *The Idea of Poverty: England in the Early Industrial Age* (New York, Alfred A. Knopf, 1983; London, Faber & Faber, 1984).
6 Letter to M. and Mme. Francis Wey, Ornans, November 26, 1849, in *Courbet raconté par lui-même et par ses amis*, ed. Pierre Courthion, vol. 2 (Geneva, Pierre Cailler, 1948), pp. 75–76. Translation by the author.
7 Ibid., p. 88.
8 Letter to Champfleury, Ornans, February–March 1850, in *Letters*, Letter 50–1, pp. 91–94. This account differs from the one presented in the letter to M. and Mme. Francis Wey, in which Courbet describes coming across the men when he had "taken our carriage to go to the Château of St. Denis."
9 See Le Men, *Courbet*, p. 92, fig. 74.
10 Letter to Champfleury, Ornans, January (?) 1852, in *Letters*, Letter 52–2, p. 106.
11 See Diane Lesko, "From genre to allegory in Gustave Courbet's *Les Demoiselles de Village*," *Art Journal*, 38 (1979), p. 176 and p. 177, n. 51.

12 Letter to the editor of *Le Messager de l'assemblée*, Ornans, November 19, 1851, in *Letters*, Letter 51–3, p. 103.
13 Benedict Nicolson, "Courbet's L'Aumône d'un Mendiant," *Burlington Magazine*, 104:707 (February 1962), pp. 48 and 73–75 at p. 74. The entire article is extremely informative.
14 See Linda Nochlin, "Gustave Courbet's *Meeting*: A Portrait of the Artist as a Wandering Jew" (1967), in *Courbet* (London, Thames & Hudson, 2007), pp. 29–54.
15 Jules Champfleury, *Histoire de l'imagerie populaire* (Paris, 1869), pp. 76–77 and 102.
16 For an illustration and discussion of this painting, see Julian Treuherz, *Hard Times: Social Realism in Victorian Art* (London, Lund Humphries, 1987), pp. 41–45.
17 For this issue, and many others concerning the understanding of poverty in the nineteenth century (although it deals specifically with England), see Himmelfarb, *The Idea of Poverty*.

Chapter 5

1 Ségolène Le Men and others connect the work to the *fête de la vache enragée*, a satirical festival staged by Montmartre artists, Pelez included, in 1896 and 1897. A parody of the *fête du bœuf gras*—the traditional mid-Lent celebration of excess and plenty—the *fête de la vache enragée* was devoted to the poor and hungry. The name of the festival and of the canvas is derived from '*manger de la vache enragée*,' a popular phrase meaning to live in poverty or to go through hard times. See Isabelle Collet (ed.), *Fernand Pelez: La parade des humbles*, exh. cat., (Paris, Paris Musées, 2009), pp. 78–85.
2 Rosenblum avoided the temptation to choose one of the sideshow paintings as the source for the other but argued that "in view of their near-simultaneous exhibition…and given the huge size of Pelez's painting… [*Grimaces and Misery*] must have been well underway, like *La Parade*, in 1887." See Rosenblum, "Fernand Pelez, or The Other Side of the Post-Impressionist Coin," in *Art, the Ape of Nature: Studies in Honor of*

H. W. Janson, eds Moshe Barasch and Lucy Freeman Sandler (New York, Harry N. Abrams, 1981), pp. 711–12.

3 "Charity of bread for all, popular soup kitchen founded in 1885."

4 "Il y a de la boue dans son pinceau [...] c'est plat, c'est gris, c'est froid et terne." Cited in *Fernand Pelez* (2009), p. 119.

5 For an excellent and comprehensive study of Raffaëlli see Marnin Young, "Heroic Indolence: Realism and the Politics of Time in Raffaëlli's *Absinthe Drinkers*," *Art Bulletin*, 90:2 (June 2008), pp. 235–59. Young points out the functions of Realism's pictorial temporality in Raffaëlli's representations of down-and-out old men, figures like the set of déclassés portrayed in the *Absinthe Drinkers*, living at the margins of modern life, quite literally occupying the periphery of the *terrain vague*.

6 The remainder of the text is adapted from Linda Nochlin, "Van Gogh, Renouard, and the weaver's crisis in Lyon: the status of a social issue in the art of the later 19th century," in Barasch and Sandler (eds), *Art, the Ape of Nature*, pp. 669–88.

7 Vincent van Gogh, *The Complete Letters* (Greenwich, CT, New York Graphic Society, 1959), vol. 3 (R14), pp. 334–35.

8 This appeared in the *Graphic* of February 18, 1871. See *English Influences on Vincent van Gogh*, exh. cat. (Nottingham and London, University of Nottingham and Arts Council of Great Britain, 1974–75), fig. 25, and another variant of the same work that Herkomer also did as a painting, *The Last Muster* of 1875, of which Van Gogh owned a copy. For Renouard's interest in the same theme of the old soldier-pensioner see his series of old pensioners at the Invalides, *L'Illustration*, 88 (1886), pp. 124–25, 128–29, 144, 145.

9 See *English Influences* (1974–75), fig. 109.

Conclusion

1 See Alison Light, *Common People: The History of an English Family* (London, Fig Tree, 2014).

2 See Ivy Pinchbeck, *Women Workers and the Industrial Revolution, 1750–1850*, (1930; London, Virago, 1981), p. 4.

ACKNOWLEDGMENTS

There are many people I would like to thank for their help, their ideas and their support. Special thanks must go to my colleagues at Thames & Hudson, including Roger Thorp, Amber Husain, Kate Duncan and Julia MacKenzie, for their patience, devotion and assistance throughout the production of this book. For intellectual stimulation, wise counsel and encouragement, I am, as always, grateful to my friends and colleagues, including Tom McDonough, Aruna D'Souza, Tamar Garb, John Goodman Jr., Marni Kessler, Ewa Lajer-Burcharth, Molly Nesbit, Abigail Solomon-Godeau and Shandor Hassan. I am also grateful to my industrious graduate assistants Daniella Berman, Bobby Brennan, Thisbe Gensler and Thea Smolinski. Without the aid of my research assistant Gabriela Van Auken, I would not have been able to complete this book. Nearly last but not least, I am grateful to all of the participants in my 2010 graduate seminar titled "Misère: The Representation of Poverty, Deprivation, and Abjection from Courbet to the Present in France, England, and the United States" and my 2011 colloquium on "The Representation of Poverty in the 20th Century" at the Institute of Fine Arts, New York University. Finally, I would like to thank all the members of my family for their generous assistance and support.

PICTURE CREDITS

2 Burrell Collection, Glasgow, Scotland / CSG CIC Glasgow Museums Collection / Bridgeman Images 6 National Folklore Collection, University College Dublin, Ireland. 11 Culture Club / Getty 20 Hulton Archive / Stringer / Getty 29 Courtesy Steven Taylor / Views of the Famine 32 Photo The Granger Collection / Topfoto 34–35, 37 Photo Illustrated London News Ltd / Mary Evans 38al Photo12 / UIG via Getty Images 38ar bpk / Skulpturensammlung und Museum für Byzantinische Kunst, SMB / Antje Voigt 38b Photo Fine Art Images / Heritage Images / Scala, Florence 40 Courtesy Steven Taylor / Views of the Famine 41 Library of Congress, Prints & Photographs Division, FSA/OWI Collection, Washington DC [LC-DIG-fsa-8b29516] 44al, 44bl Courtesy Steven Taylor / Views of the Famine 44br Photo Illustrated London News Ltd / Mary Evans 47a Mary Evans 47b Courtesy Steven Taylor / Views of the Famine 48 National Gallery of Ireland, Dublin. Presented, Mr Michael Shine, 1992. 49 National Folklore Collection, University College Dublin 52a Photo Granger Historical Picture Archive / Alamy 52b Photo Eric Nathan / Alamy 54a Photo Michael Dwyer / Alamy 54b Photo Liam Blake 55 Photo Greg Weight. Courtesy the Artists and GAGPROJECTS Adelaide / Berlin 57–59 Shandor Hassan 62a The J. Paul Getty Museum, Los Angeles. 62b Musée des Beaux-Arts de Nice. 64a Musée d'Orsay, Paris 64b Metropolitan Museum of Art, New York / Rogers Fund, 1951. 65 Courtesy National Gallery of Art, Washington / Chester Dale Collection. 71a Musée Picasso, Paris 71b Metropolitan Museum of Art, New York / Harris Brisbane Dick Fund, The Elisha Whittelsey Collection, The Elisha Whittelsey Fund and C. Douglas Dillon Gift, 1968. 77–78 Bibliothèque nationale de France, Paris 79r Wikicommons / CC-PD-Mark 1.0 82a, b The Trustees of the British Museum 83 Victoria and Albert Museum, London 84 The Trustees of the British Museum 88 Ashmolean Museum / Mary Evans 90 Castle Howard Collection / Mary Evans 91 Beinecke Rare Book and Manuscript Library, Yale University 92 Bibliothèque nationale de France, Paris 93, 94 Wellcome Library, London / CC BY 4.0 96 Photo Museo Nacional del Prado / Scala, Florence. 99al Courtesy National Gallery of Art, Washington / Woodner Collection. 99ar Photo Museo Nacional del Prado / Scala, Florence. 100al The Trustees of the British Museum. 100ar Courtesy National Gallery of Art, Washington / Rosenwald Collection 101 The Trustees of the British Museum 103 Parliamentary Papers. Session 1842. Originally published/produced in London, 1842. British Library Board. All Rights Reserved / Bridgeman Images 105 Gift of the Museum of the City of New York / The Museum of Modern Art, New York/Scala, Florence 106 Library of Congress Prints and Photographs Division Washington, D.C. NCLC Collection, [LC-USZ62-12880] 108b Library of Congress Prints and Photographs Division Washington, D.C., FSA/OWI Collection, [LC-USF342--T01-008147-A] 109l Columbus Museum of Art, Ohio. Photo League Collection, Museum purchase with funds provided by Elizabeth M. Ross, the Derby Fund, John S. and Catherine Chapin Kobacker, and the friends of the Photo League. 2001.020.147 109r Fred W. McDarrah / Getty Images 116–17, 118 Musée d'Orsay, Dist. RMN-Grand Palais / Patrice Schmidt 120 Photo RMN-Grand Palais (Musée d'Orsay) / Tony Querrec 121 Burrell Collection, Glasgow / Culture and Sport Glasgow (Museums) / Bridgeman Images. 122 akg-images. 125 Musee Municipal, Dole, France / Bridgeman Images 126 Metropolitan Museum of Art, New York / Gift of Harry Payne Bingham, 1940. 129 Josse Fine Art / Josse Christophel / Diomedia. 133 Victoria and Albert Museum, London 138a Petit Palais / Roger-Viollet / Mary Evans 138b Superstock / Diomedia. 139 Petit Palais / Roger-Viollet / Mary Evans 140al Photo RMN-Grand Palais (Musée du Louvre) / Stéphane Maréchalle. 140b Photo RMN-Grand Palais / Thierry Olivier. 141 Photo Fine Art Images / Diomedia 142t, b Petit Palais / Roger-Viollet / Mary Evans 144–45 Petit Palais / Roger-Viollet / TopFoto 147 Metropolitan Museum of Art, New York / Bequest of Stephen C. Clark, 1960. 148a, b Photo RMN-Grand Palais / François Vizzavona 150l, 150c, 150r, 151l, 151r Petit Palais / Roger-Viollet / Mary Evans 153 Christie's Images, London/ Scala, Florence. 154 Helen Birch Bartlett Memorial Collection, 1926.253. The Art Institute of Chicago © 2016 Estate of Pablo Picasso / DACS. Photo TopFoto. 156l, c Kröller-Müller Museum 156r Peter Horree / Alamy Stock Photo 162a, b The Trustees of the British Museum

171

INDEX